John Linnell
A Centennial Exhibition

John Linnell

A Centennial Exhibition

Selected and catalogued by
Katharine Crouan

Fitzwilliam Museum, Cambridge
5 October–12 December 1982

Yale Center for British Art, New Haven
26 January–20 March 1983

Cambridge University Press
Cambridge
London New York New Rochelle
Melbourne Sydney

Fitzwilliam Museum
Cambridge

Published by the Press Syndicate of the University of Cambridge
The Pitt Building, Trumpington Street, Cambridge CB2 1RP
32 East 57th Street, New York, NY 10022, USA
296 Beaconsfield Parade, Middle Park, Melbourne 3206, Australia
and by the Syndics of the Fitzwilliam Museum, Cambridge

First published 1982

Printed in Great Britain at the
University Press, Cambridge

British Library Cataloguing in Publication Data

Crouan, Katherine
 John Linnell: a centennial exhibition.
 1. Linnell, John 2. Fitzwilliam Museum –
 Exhibitions – Catalogs 3. Yale Center for
 British Art – Exhibitions 4. Landscape painting,
 English – Exhibitions
 I. Title II. Fitzwilliam Museum
 III. Yale Center for British Art
 758'.1'094207402659 ND1354.5

ISBN 0 521 24737 3 hard covers
ISBN 0 521 28923 8 paperback

Library of Congress catalogue number: 82–1232

Contents

Foreword

The idea to mark fittingly in an exhibition the centenary of John Linnell's death was put to the Fitzwilliam with sympathetic enthusiasm by one whose proper pride in descent from the painter is manifest in her own collection of his works, Joan Linnell Ivimy. She had already introduced Katharine Crouan to those other members of the Linnell family who had inherited choice examples in his work; and she had given her further, invaluable encouragement in pursuit of her studies of an artistic achievement which had been so much misunderstood or forgotten. In this rare combination of a discriminating collector and of a dedicated specialist in the making we recognised an impulse providing enough focus to go ahead. I know that Miss Crouan, to whom we entrusted the selection and the cataloguing of this exhibition, would wish to join us in thanking so understanding and helpful a patron as she has had.

In expressing gratitude to these two ladies, I would express also gratitude to my own staff in the Department of Paintings and Drawings who have patiently and skilfully collaborated on the subject, particularly Duncan Robinson, now Director of the Yale Center for British Art, and David Scrase, his successor here as coordinator of the catalogue material and the display. Mr Robinson has confirmed the interest of his predecessor at New Haven, Dr Edmund Pillsbury, in providing a second, highly appropriate venue for the exhibition in the first months of 1983.

To the Director and Council of the Paul Mellon Centre for Studies in British Art in Bloomsbury, we owe timely support of the photographic campaign required for the illustration in black and white of the catalogue, and of reproducing a selection of works in colour. We take special pleasure in this fresh instance of Yale and Cambridge working together. Our thanks also go to the Arts Council of Great Britain for its contribution towards the costs, particularly the cost of assembling from widespread places and eventually returning the many loans on which the variety and interest of the exhibition so largely depend; to FORBES Magazine for helping to defray the cost of borrowing *The Eve of the Deluge* from Cleveland; and to the Office of Arts and Libraries for obtaining the cover of a Treasury Indemnity, without which we could not have proceeded.

Our chief indebtedness, however, is to the long role of public and private lenders headed by Her Majesty The Queen who in readily appreciating the significance of the occasion have consented to be parted, most of them for the length of the two showings, from possessions familiar and precious to them. This generosity is most memorable.

MICHAEL JAFFÉ

vii

Acknowledgements

This exhibition could not have been conceived without the active support and constant encouragement of Joan Linnell Ivimy, F.L.S., who also provided me with access to the family papers, which I have permission from the Linnell Trust to quote.

I should also like to thank all members of the Linnell family who have helped and encouraged my research: John Ivimy, John S. Linnell, Air Chief Marshal Sir Nigel Maynard, K.C.B., C.B.E., D.F.C., A.F.C., Mrs Gillian Lewis and Mrs Sibyl Johns, Barbara Chidell, Hugh Linnell and Mrs Geraldine Lucas.

Duncan Robinson and David Scrase of the Fitzwilliam Museum were particularly patient and encouraging.

I would like to thank all those lenders, public and private, who have generously contributed to the exhibition and given permission for the reproduction of photographs: Her Majesty The Queen; The Martyn Gregory Gallery, London; Mrs Richard Selle, New York; Sir John and Lady Witt; the Visitors of the Ashmolean Museum, Oxford; the Trustees of the British Museum; The Bury Art Gallery & Museum; The Cleveland Museum of Art (Ohio), Purchase, Mr & Mrs William H. Marlatt Fund; The Courtauld Institute Galleries, London; the Syndics of the Fitzwilliam Museum, Cambridge; The FORBES Magazine Collection, New York; The Glasgow Art Gallery & Museum, Kelvingrove; The Harris Museum & Art Gallery, Preston; The Royal Borough of Kensington & Chelsea, Libraries & Arts Services, Leighton House Art Gallery & Museum, London; The Linnean Society of London; The Paul Mellon Centre for Studies in British Art (London) Ltd; The Museum of London; the Trustees of the National Portrait Gallery, London; The Trustees of the Tate Gallery, London; The Victoria & Albert Museum, London; the Yale Center for British Art, Paul Mellon Collection, New Haven, Conn.; and The Walker Art Gallery, Liverpool.

Particularly helpful in the course of my research have been Paul Goldman, British Museum; Andrew Ashton, Bury Museum & Art Gallery; Judy Egerton, Tate Gallery; Mary Bennett and her colleagues at the Walker Art Gallery, Liverpool; Michael Kauffman and the staff of the Prints & Drawings Department of the Victoria & Albert Museum; and the staffs of the Witt Library, the National Art Library at the Victoria & Albert Museum, the London Library and the Winchester School of Art Library.

I am especially grateful to Derek Sharpe; to Christiana Payne, who generously shared her research on Linnell; and to my husband, William Crozier, for practical information about the techniques of landscape painting. K.C.

Introduction

A visit to the large retrospective exhibition of John Linnell's work at the Royal Academy in 1883 would have prompted no such reappraisal of the painter as is proposed by the present one. When he died in 1882 his position in English art seemed secure. He had been described in the *Art Journal* and the *Athenaeum* as 'our greatest English naturalist'; he was probably the most successful landscape painter in the country after the death of Turner in 1851. Subsequently his reputation underwent a more severe reversal than those of his contemporaries. Any appreciation of his work became increasingly obscured by what was known of his personal life, and in particular by his relationship to Samuel Palmer and William Blake. Linnell's temperament and beliefs remain the best clues to understanding his work. He was a dissenter on both accounts; a radical non-conformist whose theories of nature, beauty and art estranged him from the English art establishment of his time.

In 1853, Linnell defined the kind of 'poetical landscape'[1] which he saw as the object of his life's work: 'The business of the art should be to create spiritual perceptions, and all the powers of imitation, the skill in design, in colouring and expression – all are to be used to this end.'[2]

This interpretation of landscape painting finds its origins in the somewhat contradictory theories of landscape art which Linnell encountered in his earliest training, at John Varley's 'Academy' and at the Royal Academy Schools. Varley's work, and the landscape paintings of his associates at the Society of Painters in Water-Colours, concentrated on the picturesque landscape idiom, particularly with views of North Wales, Scotland and the Lake District. Linnell joined the Varley household at the very time that the Society was being founded, and although his connection with John and Cornelius Varley now seems remarkable chiefly for the advocacy of working out of doors in oil colours (see cat. nos. 1–4), the subject matter of this work is the stock-in-trade of the Picturesque: gnarled trees; broken fences; tumbledown buildings. Although Linnell stresses the amount of time he spent working direct from nature in the company of William Mulready and William Henry Hunt ('copying Varley's drawings formed no part of the pupils employment, they were constantly drawing from nature or trying to compose')[3] it is hardly likely that a thirteen-year-old, apprenticed to a leading watercolourist of the day, would have been unaffected by the advice which John Varley later published as his *Principles of Landscape Design*.[4] Yet the small landscapes in oils done in 1806, when Linnell worked closely with William Henry Hunt from Varley's house on the Thames at Millbank, are no mere clichés of picturesque imagery. One can imagine the

importance of William Mulready in drawing Linnell's and Hunt's attention to the particular forms, colours and textures of the motif, though the colouring of these small panels bears out Sir George Beaumont's criticism that though Linnell painted 'with extraordinary fidelity – upon a small scale' the colouring was 'muddy'.[5]

Linnell's intimate association with William Mulready provided him with an artistic mentor and an intellectual bridge between the Varley method of studying landscape (going direct to nature) and the Royal Academy Schools, where Linnell would have immediately encountered the idea that the patient observation and recording of nature was not, in itself, art. Nature, according to Reynolds, Fuseli, Opie and Flaxman, all of whose lectures Linnell read or heard at the Academy, had to be transformed by the painter into an ideal version of itself. Linnell's years at the Royal Academy from 1805 to 1812 were spent under the 'wise neglect' of Fuseli in the company of B. R. Haydon, David Wilkie and Mulready, and later William Collins and C. R. Eastlake. Theirs was a generation whose student years coincided with the national and cultural isolation provoked by the Napoleonic Wars; between 1802 and 1815 they were cut off from those examples of ideal art that they were supposed to study and emulate. Apart from the Raphael cartoons, there were very few examples of High Renaissance art in London's galleries or salerooms. Much of their understanding of ideal form in painting had to be founded on copies and prints of the Old Masters. Linnell writes of this time: 'not that I had seen M. Angelo's frescos but I had seen the Cartoons of Raphael and others of that School ... from which I felt persuaded that the colouring was of the same spiritual quality as the design'.[6]

At the Royal Academy Schools Linnell was taught to see classical Greek and Roman art as a form of realism. He shared the enthusiasm of Haydon and Wilkie for the recently exhibited Elgin marbles, which, in Hazlitt's words, were regarded, in contrast with High Renaissance art, as nature itself: 'Nature, a cast from it, and the Elgin Marbles are the same; and all three are opposed to the fashionable and fastidious theory of the ideal.'[7]

But how were these theories of classical art to be applied to landscape? In Linnell's view the only modern artist who worked on the same principle as the Greeks was William Mulready, who 'endeavoured by copying beautiful nature faithfully to do as the Greeks had done – to produce something that was not second hand but from enlightened original perceptions'.[8] Linnell here refers only to Mulready's method. The subject matter of both artists still relied on the Picturesque. Following Gainsborough's practice, Mulready and Linnell set up small still-life models of landscapes, which were 'carefully chosen picturesque specimens and ... through the practice of very carefully copying all the beautiful varieties of tint and texture ... we learnt to see beauty in everything'.[9] Linnell's choice of subject matter was further conditioned by the copies of drawings by Girtin and Gainsborough which he made for Dr Thomas Monro. In 1806–7 he went with William Henry Hunt to Monro's house at 8 Adelphi Terrace. By studying and copying the work of earlier artists in that famous 'temple of the Picturesque', Linnell became part of the important succession of English artists

who extended into the new century the tradition and iconography of picturesque landscape.

Another early influence on Linnell was Benjamin West, whom Linnell visited each week in 1804–5. On the assumption that West's advice to Linnell was of the same unorthodox sort as that given to Constable and Andrew Robertson, here was a powerful incentive to go direct to nature to record its forms and colours, however transient they might be. Linnell tells us that West particularly admired the thumbnail sketches he had made of workmen in Russell Square, where the fast black and white crayon marks on rough paper give an accurate rendering of light and shade (cat. no. 6).

Many of the early drawings in the exhibition remind us that Linnell was a Londoner. He was born and bred in the parish of St Giles, then being transformed from a slum area for itinerant Irish into the squares and terraces of Georgian Bloomsbury. The view into the Linnell family's back kitchen at No. 2 Streatham Street (cat. no. 5), with its small window, bundles of washing and general pokiness, shows that in his early life the artist saw little enough of rural nature in his immediate vicinity. Like Turner, Varley, Girtin and Morland, Linnell's impulse towards landscape was bred in the heart of the city.

The most powerful incentive towards outdoor naturalism came from what is perhaps an unlikely source: Linnell's religious conversion in 1811. This aspect of the artist's life is the one which is best known yet at the same time least understood. Nominally an Anglican, Linnell's conversion led him, through the mediation of Cornelius Varley, to the Baptist community at Keppel Street. He admired both the democratic organisation of the Baptists and their system of beliefs. He found in the congregation of artisans and tradesmen a sympathetic social group and a large potential market for portraits. Later in life he rejected the Baptists for the more pietistical principles of the Plymouth Brethren, and finally he abandoned all organised religion in favour of his own interpretation of the Scriptures. He believed passionately in the supremacy of the individual and the equality of all men; views which endeared him neither to the social establishment of his time nor to those artists, like Constable, who aspired to be part of it.[10]

In 1811, however, Linnell's beliefs were based firmly upon William Paley's *Natural Theology*. They led him to understand landscape and the meticulous organisation of its design as direct proof of God's existence. 'Truth to nature' became very much more than a style or an aesthetic; since nature was God's creation, the artistic act of witness could only take the form of accurate description, as witness the drawings of the appearance of a comet in 1811 and the eclipse of the sun in 1816 in a sketchbook in the British Museum. Accuracy became a moral obligation. The immediate effect of this spiritual revolution heightened the realism and consequently the intensity of his landscape drawings. *Primrose Hill* of 1811 (cat. no. 14) is an excellent example, in which Linnell pays an obsessive attention to the texture of the ground, yet remembers the sculptural form of the land beneath, creating a dynamic tension between surface and structure. The drawing must have been done as his period at the Royal Academy drew to a close. In it are fused the knowledge he gained there, his debt to the Picturesque and his love of nature inspired by religious fervour.

The religious impulse provided the motivation for Linnell's searching exploration of visual appearances. There was no room in such an approach for artistic formulae or the use of symbolism. In his paintings from 1811 onwards, Linnell moved away from formal compositions and picturesque detail towards the less contrived depiction of large stretches of open countryside. In doing so, his aim was to translate the visual phenomena of landscape into the lines, tones and colours of a two-dimensional surface. This unattainable ideal of precision led Linnell to become interested in the physiology of seeing. He bought a *camera obscura* and probably made use of Cornelius Varley's newly patented Graphic Telescope for watercolour drawings such as *Alpha Cottages* (cat. no. 29). In this composition, the schematic, flattened shapes betray the camera's unifocal vision, rather than the stereoscopic human variety. The three studies of a brick kiln (cat. nos. 18–20) of 1812 show Linnell examining the same object from different points of view and under different light conditions. In one (cat. no. 20) the kiln is placed at the extreme edge of the composition, creating a haphazard, snapshot effect. Two years later, in 1814, Linnell remained interested in visual accuracy in his work, but developed it in tone and colour. William Collins remarked in his diary: 'I think him [Linnell] right in insisting upon the necessity of making studies – without much reference to form – of the way in which colours come up against each other. The sharpness and colour of the shades, as well as the local colour of the objects, may be got in this way.'[11] It would be wrong to infer from this obsession with visual objectivity that Linnell's was an 'innocent eye'. To do so would be to ignore his great interest in the art of the past and the parameters of taste which he gained at the Royal Academy Schools and which conditioned his reactions to landscape. For instance, when he saw mountainous landscape for the first time in Wales in 1813, part of his response was recorded in terms of previous artistic achievement: 'I saw realised what had always charmed me in the Italian pictures, the backgrounds of Raphael, Titian, etc.'[12] It may also have been the memories of earlier art which led him to experience the landscape of Wales as an appropriate location for biblical subjects: 'so thoroughly did some of the valleys near Snowdon carry me away from all former associations with modern Art that I could almost fancy myself living in the times of Jacob and Esau and might expect to meet their flocks'.[13]

By 1814 Linnell was beginning to believe that no matter how much the artist concentrated on the form of his subject, landscape was always more than just the sum of its visual qualities. It is certainly the case that the more objectively truthful Linnell attempted to make his studies from nature, the more intensely personal and poetic they became. The apparent simplicity of his technique in *Dolwyddelan Valley* (cat. no. 23), where translucent colours lie in a flat patchwork, conveys all the grandeur of the bleak Welsh landscape. The crystal clarity of this vision gives landscape a metaphorical meaning, by concentrating on, or singling out, each part of it in turn.

Nor is this approach particular to Linnell, since it is a prevailing characteristic of the Romantic movement in art and literature. The same attitude is expressed as clearly, for example, in Wordsworth's *Prelude*:

The unfettered clouds and region of the Heavens,
Tumult and peace, the darkness and the light –
Were all like workings of one mind, the features
Of the same face, blossoms upon one tree;
Characters of the great Apocalypse,
The types and symbols of Eternity[14]

One visual artist who shared Linnell's conviction that all natural phenomena had an allegorical meaning was William Blake, whom Linnell met in 1818. Each understood the visible world of nature as a reflection of the spiritual world of the imagination, or of God. For Blake, 'every Natural effect has a Spiritual Cause, and Not/A Natural: for every Natural Cause only seems: it is a Delusion'.[15] For both artists each aspect of landscape, its forms, moods and effects, takes on a metaphorical significance, the subject implying a great deal more than itself; a landscape is to be read as well as seen. There was much to draw Linnell and Blake together, especially in their characters and in the dissenting turn of their beliefs. Both despised the manners of polite society and were aggressively proud of their working-class origins. And although the differences between their work may seem more apparent than any similarities, the bond of respect which prompted Linnell to commission the Job engravings and Dante plates, and which led to their collaboration on a projected annual publication with plates by both artists, should be remembered.[16] Moreover, Linnell and Blake shared an important interest in early Flemish and German artists: van Eyck, Dürer and Lucas van Leyden. For Blake, the study of prints by Dürer and Lucas at the British Museum and at the house of the German banker Charles Aders encouraged his sharply linear style of drawing. For Linnell, on the other hand, the fastidious technique and attention to detail of the earlier artists were yet another example of the power of naturalism in art. Linnell always used the empirical observation of material fact to convey his ideas. He never relied on an imaginary landscape of the mind as Blake did, nor did he, at this stage in his career, distort a local landscape to fit his personal vision. One of the few examples of Linnell's work done at Shoreham with Samuel Palmer (cat. no. 65) particularises the greatest distinction between the two artists. Linnell's drawing in all its muted colouring and sparkling detail seems to stress the ordinariness of the Kentish valley, although two drawings of the same period (cat. nos. 63, 64) remind us of the forceful calligraphic quality of many of Palmer's drawings. *The Weald of Kent* (cat. no. 63) is one of very few drawings by Linnell in which the dramatic effect of the marks made by the pen eradicates the sense of place. Throughout the 1820s the master-pupil relationship which existed between Linnell and Palmer was as productive as the interconnections between their work. Linnell's exhortation to Palmer to study nature was responsible for the almost hallucinatory quality of the detail in *Lullingstone Oaks* or *Sepham Barn* of 1828. A further resource of Linnell and Palmer was the language of biblical typology that they came to share. In 1828, Linnell wrote to Palmer: 'Pray inform me ... if the harvest is begun in your part yet for I should like to see something of that glorious type of the everlasting harvest of spirits, the gathering of the saints – hoping that none of us will be found among the tares.'[17]

However, it would be difficult to see any such typological symbolism in Linnell's oils of this period. *The Ferry, Itchen* (cat. no. 61) and *Southampton Water* (illustrated in the exhibition catalogue *Zwei Jahrhunderte englische Malerei* (Munich, 1980), p. 449, no. 295, now in a private collection in England), companion paintings of 1825 and 1824–5 respectively, show Linnell's commitment to the locations of the paintings without resorting to the descriptive detail of topography. In *Southampton Water* it is as if Linnell had brought his recent experience of the diorama, with its wide-angle-lens effect and dramatic lighting, to his perception of Southampton. The two paintings were commissioned by Chambers Hall, a Southampton collector who presumably wanted a faithful representation of his native city. There is no indication, either in the paintings or in the commission requesting them, of any symbolic content.

A simple reason for the relative infrequency of landscape oils by Linnell before 1840 is an economic one. Although he had set out in 1812 to make his reputation in 'poetical landscape', by 1817 he was married; and by 1840 he had nine children. The financial security of this household was crucial to him. When prices of paintings slumped in the general depression of trade following the end of the war in 1815, Linnell made increasing use of his abilities as a portrait painter to provide a comfortable income for himself and his family. He also bartered his skills in the building of his successive homes, and took advantage of the access the portrait painter may gain to the private collections of his sitters.

Almost all of Linnell's portraits were painted between 1811 and 1846. Thereafter, George Richmond was recommended to would-be sitters. Linnell was quite unequivocal about their place in his work: 'portraits I painted to live, but I lived to paint poetical landscape'.[18] He must have been painfully aware that however well received they were, portraits would not further either his name as an artist or his talent. Almost as a face-saving excuse he describes how portraits aided his study of landscape: 'By painting flesh and human expression I learned to paint individual nature with more force and fidelity.'[19] By 1839 he wrote to his daughter Hannah and her husband, Samuel Palmer, on their honeymoon in Italy that 'It is a mistake, I believe, to suppose that any great progress can be made in poetical landscape unless the whole heart and mind can be devoted to it.'[20] Yet it was not until 1846, when he was well over fifty, that Linnell was able to devote his full time and energy to landscape painting.

Linnell envied Palmer's tour of the Continent. He did so not for the access it provided to foreign landscape, but for the chance it gave to his son-in-law to study at first hand the art of the Italian Renaissance; the art which had provided such a potent source of inspiration for Linnell himself since his youth. He wrote to Palmer, 'I am like a servant who has only over hours for study whereas you and Mr. [George] Richmond are at college – at the great university of art.'[21] Unlike many of his contemporaries, Linnell never ventured out of England. Even Wales, once visited in 1813, was a foreign landscape to which he never returned. In Constable's phrase, he was 'a stay-at-home painter' who showed no interest in the topography of Italy or Palestine, preferring always to work within the confines of the landscape environment of his own home.

Throughout the 1830s Linnell spent more time making copies of the Old

Masters for engravers such as John Pye than he did painting either portraits or landscape. By 1839 the only public success he had enjoyed in poetical landscape was *The Disciples on the Road to Emmaus* of 1834–8 (Ashmolean Museum, Oxford), which, like *Noah: The Eve of the Deluge* (cat. no. 93) and *The Halt by the Jordan* (cat. no. 92), shows a biblical subject in an English landscape. The landscape background of each of these paintings was composed from earlier studies by Linnell. It is clear from these works that for Linnell 'poetical landscape' meant historical landscape with a religious subject; as such they fill part of an important hiatus in English painting.

A perennial problem in nineteenth-century England was the creation of a contemporary iconography for Protestant belief. David Wilkie articulated the often felt anxiety: 'A Martin Luther in painting is called for, as in theology, to sweep away the abuses by which our divine pursuit is encumbered.' He was writing to William Collins from Rome in 1842, having just seen the frescoes of Raphael in the Vatican. Voicing a sentiment which must have been close to Linnell's heart, he continued: 'The art of painting seems made for the service of Christianity. Would that the Catholics were not the only sect who have seen its advantages.'[22] The unfortunate fact remained that those who had given art its greatest devotional forms were Catholic.[23] Moreover, the very idea of Protestant imagery is self-contradictory, ignoring as it does the essential iconoclasm which is inherent in extreme forms of English Protestantism. Linnell's response to the problem was to anglicise the settings of his biblical illustrations: Emmaus is located in the Welsh mountains; the Jordan river flows through Dovedale. What is apparent in such paintings is that while the landscape backgrounds convince us by their naturalism, by the grandeur of their forms or by the drama of their colours, the biblical staffage does not. Whether Linnell used his friends as models or painted entirely imaginary figures reminiscent of Blake and Westall, the results are equally implausible. Unlike the High Churchman William Dyce, who felt no compunction in placing Raphaelesque figures in his contemporary Scottish landscapes (for example, *Jacob and Rachel* in the Leicester City Art Gallery), Linnell would have felt that to do likewise would compromise his Protestantism.

It was perhaps because of the artistic failure of his biblical landscapes, noted frequently enough in his day, that Linnell began to develop landscape itself as the only possible vehicle for overt religious expression. He could rely on his patrons' ability to read landscape as a system of symbols, since the metaphors of the Bible are almost exclusively pastoral. Sheep, harvests and storms provided no problems of historical dress or physiological authenticity; they provided the simplest, most ideal devotional image for mid-Victorian England. Proof of the theory lies in Linnell's immense popularity with that same Low Church, dissenting and entrepreneurial class of which he himself was part. There was consistency of belief between artist and patron.

Of the rare landscapes with a biblical subject, the most successful was undoubtedly *Noah: The Eve of the Deluge*. Finished in 1848, it calls to mind the still contemporary debate between Catastrophists and Evolutionists which had already inspired paintings of the same subject by Turner, Martin and Danby. The

subject was an excellent vehicle for expounding theological debate in landscape of the most spectacularly dramatic proportions. Linnell's *Noah* was much larger and more sumptuously coloured than any of his previous works. It combined a favourite theme of his – man's impotence in the face of God – with English landscape; most of the studies for the painting were done at Underriver in Kent in 1847. *Noah* made Linnell's reputation. It sold for £1,000, three times the price of any previous work of his; and it was the only biblical subject painted by him to maintain its original selling price throughout his lifetime.

St Philip Baptising the Eunuch of 1841 relied heavily in its composition on two paintings of the subject by Jan Both, in Lord Methuen's house and in the Royal Collection, which Linnell could have seen during the time of his involvement with portrait commissions. The only essential iconographic difference between Both's Baptisms and Linnell's is in the form of baptism; Linnell substitutes total immersion for the 'sprinkling' method. The alteration proved either unsatisfactory or unconvincing, for by the end of Linnell's life the saint and the eunuch had been painted out by another hand and the picture became known, as it is now, as *The Halt by the Jordan* (cat. no. 92).

Biblical subjects were never as popular with Linnell's buyers as his pastorals, and dealers were quick to point this out to the artist. Lebbeus Colls wrote to him complaining that 'I find your subjects of this character are not near so well liked ... I wish you would alter the figures for me and put in a fresh group with some sheep or other subject ... it would assist me to sell it better.'[24] Linnell reacted strongly to these entreaties. He defended the characteristics of historical landscape by citing the precedents of Claude and Poussin and the great nineteenth-century champion of the genre, Turner. Explaining the religious element of his pictures, he replied to Colls: 'When such subjects are attempted with sincerity I think the painter observes and brings out higher and more impressive qualities of nature than when treating the merely natural.'[25] If the elevated theme of the landscape determined its expressive qualities, it followed that a 'religious landscape' without figures should imply their presence by mood and form. 'Ideal art, Poetic, Imaginative or High Art', Linnell wrote, 'I suppose to result ... from a vivid perception of those qualities in nature which most affect the mind with emotions of moral sympathy, sublimity and beauty ... and the perception of these is the result of knowledge and is knowledge.'[26]

These statements appear in Linnell's only public writings on art. Written in the early 1850s, their high moral tone, as much as Linnell's continued devotion to the study of nature, recommended him to the Pre-Raphaelite group of artists. The biographies of William Bell Scott, Ford Madox Brown and William Holman Hunt confirm that, far from being condemned along with most of his generation of artists, Linnell was highly regarded by the Pre-Raphaelites. Holman Hunt and Millais visited him at Redhill in 1850, 1851 and 1854, and Linnell defended them orally at the Royal Academy Exhibition of 1851. Linnell anticipated the Pre-Raphaelites' interest in early Flemish and German art and their use of glazes over a white ground, although unlike them he does not seem to have painted wet-in-wet on the ground. He may also have absorbed his ideas about the use of white ground from William Blake, whose *Descriptive Catalogue* of 1809 explains the

clarity to be gained from its use. However, the real similarity of approach between the younger artists and Linnell is best seen by comparing Linnell's 'romantic realist'[27] drawings of 1811–18 with those Pre-Raphaelite studies of nature which followed John Ruskin's directive: 'The duty [of young artists] is neither to choose nor compose, nor imagine, nor experimentalise but be humble and earnest in following the steps of nature and tracing the finger of God.'[28] The closest comparison thus lies between Linnell's early studies, which were probably not known to the Pre-Raphaelites, and their oil paintings, which Linnell's anticipate by more than thirty years. However, a painting such as Holman Hunt's *May Morning on Magdalen Tower* of 1888–91 makes use of a fluorescent cloud formation which intrudes on the foreground action every bit as much as a Linnell sky does in his later landscapes.

Influence in the other direction took the form of pressure upon Linnell from dealers who insisted that 'in these days of Pre-Raphaelism [*sic*] in a picture the subject of which is the figures, it is quite necessary to make the work satisfactory, that they should have as much form and finish as the landscape'.[29] During the 1850s, when the precise technique of the Pre-Raphaelites set the popular fashion, Linnell's landscapes became increasingly unspecific and generalised in treatment. Dealers endlessly pressed him for 'more finish' in his work, and a painting like *Changing Pastures* of 1859 in the Guildhall, London, is one of the rare examples where Linnell acceded to their requests. At this period he normally omitted all references to particular places or specific times of day, to free his landscapes from topographical connotations. He often referred to his later pictures as 'aspects of nature' or 'spiritual artistic facts'.[30] It was as though the flickering, impressionistic brushstroke which Linnell used in his paintings after 1850 (a brushstroke which reduces everything in the landscape to the same focus and therefore to the same importance) was part of the meaning of the image, and, as such, intended to draw attention to the unreality of the painted world which Linnell has constructed into a unity of symbols. Nor was this approach unpopular. When no less a dealer than Ernest Gambart bought in several early landscapes by Linnell at an auction in Liverpool in 1853, he promptly dispatched them down to Redhill to be 'retouched in your present style'.[31] Clearly this is another reason why there are apparently so few of the early landscape oils in circulation today.

So many of Linnell's landscapes painted at Redhill after 1850 are based on studies of some decades earlier that it is tempting to conclude that this, too, was a conscious aspect of Linnell's later work. Writing to William Agnew in 1863 about the painting *Windsor Forest* (cat. no. 97), Linnell stressed that it is of 'Windsor Forest as it was 50 years ago, when I made the study for which I painted the picture'.[32] It suggests that Linnell promoted his landscapes as nostalgic reminders of change, comments on increased urbanisation and the disappearance of large parts of the English countryside. Thackeray had noticed this important aspect of landscape painting in a review of the Royal Academy of 1855: 'We English are a rural people. Few of the well-to-do residents in London feel themselves at home there. Everyone remembers with regret his country house, and looks forward with hope to returning thither at last ... What a

pleasure it is to stroll through the exhibition and renew acquaintance with streams and hills and woods.'[33] It was commonplace thinking that to live in the country was more spiritually beneficial, less morally corrupting, than to live in the town. It is noteworthy that Linnell's succession of homes in Hampstead, Bayswater and Redhill were in the countryside when he moved to them but that, by the time he left them, they had been engulfed by the sprawl of London suburbs. It seems likely that his later landscapes were intended to evoke a hazy, golden rural past. They are peopled by the picturesque, wholesome peasantry of Gainsborough's pictures, whose only upsets are caused by storms at harvest time.

Without exception Linnell's pastorals are epic in mood. They aggrandise landscape forms by exaggerating differences in scale. In *A Coming Storm* (cat. no. 98) of 1873, for instance, the features of Surrey are reduced to Lilliputian scale in order to inspire in the spectator awe for the gigantic forms of the landscape.

Although he continued to make drawings of landscape throughout his life, Linnell used his own earlier studies together with calotypes and photographs in the preparation of the oils he painted between 1851 and 1866. He made a point of seeing the first daguerreotypes as soon as they became available in London in 1839, although he does not seem to have employed photography in his work before 1851. A letter of 1863 to William Agnew gives some indication of its use. Linnell refers to the 'photo not yet arrived of Windsor Forest. I should be glad of any cows, horses, sheep and dogs to refer to for details.'[34] The importance of photography for Linnell extended beyond its application to landscape painting. For example, he was immensely excited at the prospect of having photographs of the Sistine Chapel ceiling; letters to his son William in Rome in 1867 beg to be sent copies of the first Alinari prints.

Linnell attributed his phenomenal success in selling paintings to one simple cause, 'the real knowledge of Christian doctrine and conventions',[35] but, as G. M. Young has pointed out,[36] many of the virtues of the good dissenting Christian were interchangeable with those of a successful manufacturer or salesman. Linnell played exactly the same social rôle as many of his patrons, that of a self-made industrialist; and with them he held as axiomatic the belief that success was only possible through hard work ('the grandest thing in the world')[37] – never solely through innate talent or inherited fortune.

A strongly egalitarian sense engendered his extreme dislike of all hierarchies, whether of church, state or the Royal Academy. In the earlier part of his career Linnell had submitted his name for associateship for twenty-one years in succession and had been excluded from membership each time. After failing to gain entry at a time in his life when the honour would have been helpful to him, Linnell later refused every suggestion that he should become an Academician and berated the Royal Academy as a rather unpleasant social clique. Indeed, when in the 1860s he was recognised as one of the foremost landscape painters in the country – if not the foremost – it was a source of some embarrassment to the Academy that he was not of their number. Both Millais and Eastlake used the example of Linnell and his unfair treatment by the Academy to argue for a reform

of its organisation. Linnell, who believed that the Academy was a national institution and that it should therefore include all artists, enjoyed his position as a permanent thorn in the Academy's flesh. In 1869, he refused to take part in Thomas Gullick's exhibition of rejected painters, modelled after the Salon des Refusés.

Linnell's career began in the era of West and Lawrence; it lasted until his death at the age of eighty-nine, and yet his reputation outlived him by less than ten years. Alfred Story's biography of 1893 can only have reinforced the impression that Linnell's art and ideas were hopelessly outmoded. By then the aestheticism of Whistler, Sickert and the New English Art Club had begun to replace the moral overtones of Victorian taste. A growing acceptance of art for art's sake, evident in the writings of W. E. Henley, was used as a stick with which to beat Linnell and many of his contemporaries; the innovative 'outdoor naturalism' of his early work was overlooked by a generation for whom Linnell was characterised by his exhibited work in oils.

In an account of Linnell's *critica fortuna*, the rôle of Samuel Palmer's son cannot be overlooked. In the early years of this century A. H. Palmer planned to rewrite his biography of Samuel Palmer as a joint life of the two painters. He hoped thereby to prove conclusively that Palmer's lack of success after 1839 was the fault of an overbearing father-in-law. Though the book was never written, A. H. Palmer's distinction between the 'visionary' Palmer and the 'materialistic' Linnell became the accepted view, to the great disservice of both artists. A. H. Palmer's extreme antipathy led him to omit Linnell from the important exhibition organised at the Victoria & Albert Museum in 1926, which did so much to reinstate the landscapes of Blake, Palmer and their circle and to introduce them to twentieth-century artists.

Ignorance of what may now be considered Linnell's most important contribution to English landscape painting, his drawings of 1811–18 which question the very nature of seeing landscape, accounts for the neglect of his work until recently. The proper appreciation of this important aspect of his career should not on the other hand outweigh a balanced view of his achievement. His obsessive love of nature and passionately held beliefs remained throughout his life. What started as a pantheistic delight in the experience of nature settled into the study of dogma; the purely visual qualities which distinguish the early work gave way to a literal symbolism. Linnell's later epic pastorals are immediately recognisable, perhaps because he was one of the very few landscape artists of his time to overcome the trite sentimentality of pastoral subjects. Linnell made High Art his goal, and although his 'aspects of nature' are quintessentially English, their sources lie in the mainstream of European art. At a period when history painting was distinguished mostly by spectacular failures, Linnell's poetical landscapes remain among the few successes.

1. *The Bouquet*, no. 25 (1853) (no pagination). Linnell wrote under the pseudonym 'Larkspur'.
2. *Ibid.*
3. 'Autobiographical Notes', p. 7 (cited hereafter as A.N.).
4. J. Varley, *A Treatise on the Principles of Landscape Design*, 3 pts (London, 1816–18).
5. Windsor MSS., Faringdon Diary (typescript), p. 3492.
6. A.N., p. 26.
7. William Hazlitt, 'On the Elgin Marbles', in *Criticisms on Art*, ed. William Carey Hazlitt (London, 1856), vol. II, p. 241. Hazlitt's only comment on Linnell's work came in 1822 when he referred to the landscapes as 'an *experimentum crucis* to show that the worst selection of nature is better than any fanciful composition'. *Complete Works*, vol. XVIII (London, 1933), p. 169.
8. A.N., p. 16.
9. *Ibid.*, p. 38.
10. *Ibid.*, p. 25. 'Collins once threatened me with prosecution for not going to church (My State church). Constable was also very bitter upon this subject. He said that no dissenter had a head beyond a shoemaker or blacksmith meaning, I suppose, that their physiognomy expressed no capacity for anything beyond such occupations.'
11. W. Wilkie Collins, *Memoirs of the Life of William Collins Esq., R.A.* (London, 1848), p. 58.
12. A.N., p. 45.
13. *Ibid.*, p. 46.
14. W. Wordsworth, *The Prelude*, bk VI, lines 634–9, in *The Poetical Works of William Wordsworth* (Oxford, 1960), p. 536.
15. William Blake, *Milton a Poem in 2 Books*, lines 513–14.
16. Linnell MSS., letter to Samuel Palmer, 7 Aug. 1828.
17. Letter to Samuel Palmer, 7 Aug. 1828, quoted in R. Lister (ed.), *The Letters of Samuel Palmer* (2 vols., Oxford, 1974), I, p. 25n.
18. A.N., p. 13.
19. Linnell MSS., letter to Hannah Palmer, 30 Sept. 1839.
20. *Ibid.*, letter to Samuel Palmer, 1839.
21. Collins, *Memoirs*, p. 105.
22. Quoted in W. Bayne, *Sir David Wilkie R.A.* (London, 1903), p. 118.
23. A.N., p. 75: 'The Italian Painters were papists, it may be said, and how was it they painted with such purity of taste, as Raphael, for instance... They were born in the idols temple, but their faces were towards Jerusalem.'
24. Linnell MSS., Lebbeus Colls to Linnell, n.d. (1855–60).
25. *Ibid.*, letter to Lebbeus Colls, n.d. (1855–60).
26. *The Bouquet*, no. 25 (1853).
27. The term was coined by Geoffrey Grigson in his article 'Gordale Scar to the Pre-raphaelites' in *The Listener*, 39 (1 January 1948). 'The strain is both realistic and penetrated from beneath, from depths of being, with what Jung would call the archaic and the primitive.'
28. J. Ruskin in *Modern Painters I* in *Complete Works*, ed. E. T. Cook and Alexander Wedderburn (38 vols., London, 1903–12), vol. III, p. 623.
29. Linnell MSS., C. M. Wass to Linnell, 17 Dec. 1853.
30. *Dublin University Magazine*, no. 90 (Nov. 1877). 'What he paints he regards as aspects of nature and not topography; this is a spiritual artistic fact.'
31. Linnell MSS., Ernest Gambart to Linnell, 20 Sept. 1853.
32. *Ibid.*, letter to William Agnew, 20 Sept. 1853.
33. W. M. Thackeray, 'A Review of the Royal Academy Exhibition', *Fraser's Magazine*, June 1855, p. 713.
34. Linnell MSS., letter to William Agnew, 16 June 1863.
35. A.N., p. 52.
36. G. M. Young, *Portrait of an Age: Victorian England* (Oxford, 1973), p. 2.
37. Letter to William Agnew, 1863, quoted in R. Lister, *Samuel Palmer: A Biography* (London, 1974), p. 39.

Biographical outline

1792	16 June: born in Rose Street, Bloomsbury, the third child and first son of James and Mary Susanna Linnell. James Linnell was a frame-maker. His uncle was the furniture-maker John Linnell (d. 1796).
c. 1796	James Linnell's business failed when his partner defaulted.
1800	The family moved to 2 Streatham Street, Bloomsbury, where James Linnell re-established himself as a frame-maker, gilder and restorer of pictures.
1800–4	Copied engravings after George Morland for his father to sell. He did not attend school, but taught himself to read and write.
1800	Introduced to Benjamin West, P.R.A., who corrected his drawings for him, presumably with a view to gaining entrance to the Royal Academy Schools.
1804–5	Apprenticed to John Varley at William Mulready's instance.
1805	Entered the Royal Academy Schools as a probationer.
1806	Painted in oils out of doors at Twickenham with Mulready and William Henry Hunt. Linnell and Hunt worked in the evenings for Dr Thomas Monro, copying from his collection of drawings by Girtin and Gainsborough.
1808	Visited Chatham and Hastings with Mulready. Took lodgings in the Hampstead road.
1809	Divided his time between Streatham Street and Mulready's lodgings at Kensington Gravel Pits. Won 50-guinea premium at the British Institution for *The Woodcutters* (untraced).
1810	Won medal at the Royal Academy Schools for modelling in low relief. Began to give drawing lessons.
1811	Attended Flaxman's first lecture on sculpture at the Royal Academy and Turner's lectures on perspective. Visited Dover with James Linnell. Left Royal Academy Schools. Bought a *camera obscura*. Moved to his own lodgings at 11 Queen Street, Edgware Road. Religious awakening. Baptised a member of the Baptist community at Keppel Street, Bloomsbury. First portrait commission (from Ridley Colbourne).
1812	Founder member of the Society for Painters in Oil and Water-Colours.
1813	First important sketching tour – to North Wales with G. R. Lewis, the engraver. Showed landscapes at the Society of Painters in Oil and Water-Colours. Worked for C. Pugin on his *Views in Islington*

and Pentonville and completed paintings for John Varley and Sir Thomas Lawrence. Became engaged to Mary Ann Palmer, daughter of the Baptist scholar Thomas Palmer (no relation of Samuel Palmer).

1814 Travelled to Hertford and Derbyshire to prepare drawings for illustrations to the Walton and Cotton edition of *The Compleat Angler* commissioned by Samuel Bagster.

1815 Made studies from nature in Windsor Forest; travelled to Kingsclere, Newbury, Southampton and the Isle of Wight. Attended Sir Humphrey Davy's lecture on 'some experiments and observations on the colours used in painting by the Ancients', Royal Society, 23 February.

1816 August: Visited Cirencester and Bognor.

1817 Travelled to Scotland to be married by civil ceremony to Mary Ann Palmer. Returned to London via the north-east coast to take up lucrative portrait commissions. Rented rooms in Rathbone Place.

1818 Introduced to William Blake by George Cumberland junior. Went with Blake to study Lord Suffolk's collection of pictures, and to the British Museum to see prints by Dürer, Marcantonio Raimondi and Bonasone. Moved to 6 Cirencester Place where first child, Hannah, born.

1819 Visited Southampton where he lodged with D. C. Read, a local artist and acquaintance of Constable. Dispute between Linnell and Read fuelled Constable's dislike of Linnell. Introduced William Blake to the Linnell family doctor, who later commissioned illustrations from Blake for his translation of Virgil's *Eclogues*.

1820 Resigned from Society of Painters on Oil and Water-Colours. Bought a *camera lucida*. Friendship with Sir Thomas Lawrence. Second daughter, Elizabeth Ann, born.

1821 Exhibited landscapes at the Royal Academy after a gap of seven years when he had shown only portraits there. Applied for Associate Membership. Rejected but continued to apply for the next twenty years with equal lack of success. First son, John, born.

1822 Met Samuel Palmer. Bought a painting by 'Lucas van Leyden'.

1823 Rented part of Collins's Farm, North End, Hampstead, but maintained his rooms at 6 Cirencester Place. Commissioned William Blake to make engravings from his 1805–10 drawings of the Book of Job. Son James Thomas born.

1824 Rented the whole of Collins's Farm. Helped Blake to print the proofs of *Job*. Met Mr and Mrs Charles Aders of Euston Square, London, and through them Henry Crabb Robinson, Stothard and Flaxman. Commissioned by Aders to make a copy of part of their copy of van Eyck's Ghent altarpiece.

1826 Enlarged the accommodation of Collins's Farm. Son William born.

1827 William Blake died (12 August). Catherine Blake temporarily moved into 6 Cirencester Place.

1828	Ill from nervous exhaustion. Visited Shoreham to see Palmer and sketch from nature. Moved into new house at 38 Porchester Terrace, Bayswater, in London. Introduced to Samuel Rogers by George Cumberland junior. Third daughter, Mary Ann, born. Met E. T. Daniels and agreed to give him lessons.
1829–38	Copied paintings in the National Gallery for John Pye, for engraving.
1830	Daughter Sarah born.
1831	Called for military service. Pleaded incapacity and found substitute. Death of Catherine Blake.
1831–4	Much time devoted to copies of the Old Masters for sale to engravers.
1834	Published *Michelangelo's Frescoes in the Sistine Chapel* made earlier from drawings in Samuel Rogers Collection. Bought a copy of Flaxman's letters. Travelled to Westminster to see and make drawings of the fire of the Houses of Parliament (untraced). Set Palmer to work on still-lifes.
1835	Visited Lord Lansdowne's collection of pictures at Lansdowne House and Sir Robert Peel's collection. Gave evidence on the authenticity of a painting by Claude at the Old Bailey. Twins, Thomas George and Phoebe, born.
1837	Hannah Linnell married to Samuel Palmer.
1838	*The Disciples on the Road to Emmaus* purchased by the Art Union.
1839	25 September: went to Royal Institution to see examples of daguerreotypes of the Parisian boulevards. John, James and William Linnell became students at the Royal Academy. Hannah and Samuel Palmer back from their honeymoon in Europe.
1840	Patronised by Art Union prize-winners from the North of England as patrons. 29 May: went with E. T. Daniell to examine Danby's picture *The Deluge*. Summer at Underriver, Kent.
1841	Met William Dyce and J. R. Herbert. Sketching tours to Thatcham, Newbury, Kingsclere and Donnington.
1841–3	Met William Conningham. Joined Plymouth Brethren. Withdrew annual application for Associate of the Royal Academy (A.R.A.).
1844	Ruskin visited Linnell and bought a copy of the Michelangelo Sistine Chapel mezzotints.
1845	Sold 17 early landscapes to the dealer Ralph Thomas for £1,000 plus a house in Hammersmith Terrace. Hereafter, as the prices of Linnell's landscapes climbed steeply, he could afford to dispense with portraiture.
1846	John Gibbon, the ironmaster from Birmingham, began to commission work from Linnell.
1847	Introduced to the dealer William Wethered by David Cox. Approached by Thomas Creswick to put his name down again for A.R.A. but refused.
1848	The great success of *The Eve of the Deluge* at the Royal Academy

established Linnell as a major landscape artist. The painting was bought by Joseph Gillott, who continued to buy from Linnell. After street riots in London in March and April, Linnell attended a Chartist meeting. Visited Balcombe on the Kent/Sussex border.

1849 Went to study the Windus Collection of Turner drawings at Tottenham. Lebbeus Colls supplied him with 'sun pictures' (early photographs). Bought land in Redhill and began to build there.

1851 Moved family to Redstone Wood, Redhill, Surrey. Many visits to the Crystal Palace Exhibition. Met and dined with Dr Waagen. Defended the Pre-Raphaelite paintings of Holman Hunt and Millais at the Royal Academy.

1852 Approached by Eastlake, Leslie and Stanfield to apply for A.R.A. Introduced to Ernest Gambart by John Pye. Millais and Holman Hunt visited Linnell at Redstone Wood.

1855 Won a gold medal at the Exposition Universelle, Paris, for *A Forest Road* (Liverpool, Sudley House). Became interested in parliamentary reform.

1856 Gambart introduced Linnell and his sons to Rosa Bonheur.

1857 Wrote to daughter Hannah that his 'working hours are few' due to failing eyesight. Forgeries of Linnell's work began to appear on the market.

1863 Millais and Eastlake defended Linnell against 'unfair' system of electing A.R.A.s at Government enquiry into the Royal Academy.

1864 Published *Burnt-Offering Not in the Hebrew Bible*, a discussion of mistranslations in the Bible.

1867 Requested photographs of Vatican *loggie* from son William in Rome.

1869 Published pamphlet, *The Royal Academy, a National Institution*, arguing against 'the elite of forty members'.

1875 First one-man show (Pall Mall Galleries).

1882 20 January: died at Redstone Wood.

Select bibliography

Unpublished sources

The Linnell MSS. collection, which includes
 (a) John Linnell, 'Autobiographical Notes'
 (Redhill, 1864), 76 pp. plus unnumbered
 sheets.
 (b) John Linnell, 'Journal', 1811–79. The
 volumes for 1812–19 are lost.
 (c) John Linnell, 'Cash Account Books',
 1811–80.
 (d) Autograph letters to and from Linnell.

British Museum
 John Linnell, 'Portrait Sketchbook' (cat.
 no. 100b).
 John Linnell, 'Landscape Sketchbook' (cat.
 no. 100a).

Victoria and Albert Museum MSS.
 (a) Correspondence between John Pye and
 John Linnell.
 (b) Correspondence between A. H. Palmer
 and Martin Hardie.

London. Royal Academy Library, Jupp
 Catalogue.

London. Courtauld Institute of Art, M.A.
 thesis by Christiana Knowles, 'John
 Linnell: His Early Landscapes to 1830',
 1980.

Windsor MSS. The Faringdon Diary.

Madison, Wisc. The University of Wisconsin,
 Ph. D. thesis by E. R. Firestone, 'John
 Linnell, English Artist: Works, Patrons
 and Dealers', 1971.

Published sources

Bentley, G. E., Jun., *Blake Records*, Oxford,
 1969.
Bindman, D., *Blake as an Artist*, Oxford, 1977.
Butlin, M., 'Blake, the Varleys and the
 Graphic Telescope', in *William Blake:
 Essays in Honour of Sir Geoffrey Keynes*, ed.
 M. D. Paley and M. Phillips, Oxford,
 1973.
Collins, W. W., *Memoirs of the Life of William
 Collins, Esq.,* R.A. *with Selections from his

Journals and Correspondence*, London, 1848.
Denvir, B., 'Pens and Patronage', *Connoisseur
 Year Book*, 1958.
Grigson, G., *Samuel Palmer; The Visionary
 Years*, London, 1947.
 'Gordale Scar to the Pre-Raphaelites', *The
 Listener*, 39 (1 Jan. 1948).
Hamerton, P. G., *Imagination in Landscape
 Painting*, London, 1887.
Hazlitt, W., *Criticisms on Art*, ed. W. C.
 Hazlitt, vol. ii, London, 1856.
Heleniak, K. M., *William Mulready*, New
 Haven, Conn., 1980.
Henley, W. E., *A Century of Painters*, London,
 1889.
Heseltine, J. P., *John Varley and his Pupils, W.
 Mulready, J. Linnell and W. Hunt*, London,
 1918.
Hueffer, F. M., *Ford Madox Brown; A Record of
 his Life and Work*, London, 1896.
Hunt, W. H., *Pre-Raphaelitism and the Pre-
 Raphaelite Brotherhood*, 2 vols., London,
 1905.
Hussey, C., *The Picturesque*, London, 1967 edn.
Hutchinson, S., 'The Royal Academy Schools
 1768–1830', *Walpole Society*, 38 (1960–2),
 123–91.
Joseph, M. K., 'Charles Aders: A Biographical
 Note', *Auckland University College Bulletin*,
 no. 43 (1953), 6ff.
Landow, G. P., *William Holman Hunt and
 Typological Symbolism*, New Haven, Conn.
 and London, 1979.
Lindsay, A. W. C. (Lord), *Sketches of the History
 of Christian Art*, London, 1847.
Linnell, J., *Michelangelo's Frescoes in the Sistine
 Chapel*, London, 1834.
 The Royal Gallery of Pictures, London, 1840.
 'Dialogue upon Art; Painter and Friend',
 The Bouquet, no. 25 (1853).
 'Dialogue upon Art; Collector and Painter',
 The Bouquet, no. 33 (1854).
 Diatheeke, Covenant Not Testament, Redhill,
 1856.

Burnt-Offering Not in the Hebrew Bible: Shown by a Revised Version of the First Part of Leviticus, Redhill, 1864.

The Royal Academy, A National Institution, London, 1869.

Lister, R., *Samuel Palmer: A Biography*, London, 1974.

Lister, R. (ed.), *The Letters of Samuel Palmer*, 2 vols., Oxford, 1974.

Newsham, R., *Catalogue of the Pictures and Drawings of the Newsham Bequest*, Preston, 1884.

Olsen, D. J., *The Growth of London*, London?, 1976.

Ormond, R., *Catalogue of Early Victorian Portraits in the National Portrait Gallery*, 2 vols., London (H.M.S.O.), 1973.

Palmer, A. H., *Life and Letters of Samuel Palmer*, London, 1893.

Catalogue of an Exhibition of Drawings, Etchings and Woodcuts by Samuel Palmer and Other Disciples of William Blake, London, 1926.

Pidgely, M., 'Cornelius Varley, Cotman and the Graphic Telescope', *Burlington Magazine*, 1972, pp. 781–6.

Pointon, M., 'William Dyce as a Painter of Biblical Subjects', *Art Bulletin*, June 1976.

William Dyce 1806–1864, Oxford, 1979.

Robinson, E. (ed.), *Letters and Papers of Andrew Robertson A.M.*, London, 1897.

Roget, J. L., *A History of the Old Water-Colour Society*, 2 vols., London, 1891.

Scott, W. B., *Autobiographical Notes of the Life of William Bell Scott*, ed. W. Minto, London, 1892.

Smetham, S., *Letters of James Smetham*, London, 1891.

Stephens, F. G., 'John Linnell', *The Portfolio – An Artistic Periodical*, 3 (1872).

'John Linnell, Painter and Engraver, Part I', *Art Journal*, 44 (Aug. 1882).

'John Linnell, Painter and Engraver, Part II', *Art Journal*, 44 (Sept. 1882).

'The Aims, Studies and Progress of John Linnell, Painter and Engraver', *Art Journal*, 45 (Jan. 1883).

Story, A. T., *The Life of John Linnell*, 2 vols., London, 1893.

James Holmes and John Varley, London, 1894.

Taylor, T., 'English Art in 1862', *Fine Arts Quarterly Review*, May 1863.

Varley, C., *A Treatise on Optical Drawing Instruments*, London, 1845.

Varley, J., *A Treatise on the Principles of Landscape Design*, 3 pts, London, 1816–18.

Vaughan, W., *German Romanticism and English Art*, New Haven, Conn., 1979.

Walton, I. and Cotton, C., *The Compleat Angler*, London, 1815 edn.

Whitley, W. T., *Art in England 1800–1820*, Cambridge, 1928.

Art in England 1821–37, Cambridge, 1930.

Wornum, R., *Lectures on Painting by the Royal Academicians*, London, 1885.

Exhibitions

London, The Pall Mall Gallery, *Exhibition of the Works of John Linnell Sen.*, 1875.

London, Arthur Tooth & Sons Gallery, *A Loan Collection of Works by the Late John Linnell*, 1882.

London, Royal Academy, *Winter Exhibition of Works by Old Masters and by Deceased Masters of the English School, Including . . . John Linnell*, 1883.

Reigate, The Town Hall, *Samuel Palmer and John Linnell*, 1963.

London, P. & D. Colnaghi & Co., Ltd, *A Loan Exhibition of Drawings, Watercolours and Paintings by John Linnell and his Circle*, 1973.

Salisbury, The City Library, Salisbury Festival Exhibition, *John Linnell 1792–1882*, 1977.

1 The Willow – Study from Nature

Oil on board. 25.5 × 16.5 cm
Signed and dated, *verso*, 'J Linnell 1806'
COLLECTIONS: By descent from James Linnell to the present owner
EXHIBITION: Reigate, 1963, no. 32

This and cat. nos. 2–4 are among the works done by Linnell while apprenticed to John Varley, 1805–6. In his 'Autobiographical Notes' Linnell writes of this period: 'Hunt [William Henry Hunt, 1790–1864] and I were always out, weather permitted, painting in oil on millboard from nature.' Despite being Varley's student, Linnell was at pains to point out that he 'always received more instructions from Mull [William Mulready, 1786–1863] than from anyone, indeed I feel bound to say that I owe more to him than to anyone I ever knew'. It might be expected, therefore, that Linnell's and Mulready's oils of 1806–7 would be very similar, but this is not in fact the case. Mulready, six years older, shows a correspondingly greater confidence in his handling of oil paint, which allows him a more spontaneous, bravura technique. (See K. M. Heleniak, *William Mulready* (New Haven, Conn., 1980), no. 17 – *Hampstead Heath*.) Linnell's work, by comparison, is much more tentative and painstaking. This study by Linnell may be compared with a similar *Study from Nature at Twickenham* by William Henry Hunt which is in the Tate Galley (T.1154). Though the style of the two artists is very close, Linnell uses a drier, less fluid paint and concentrates on building up form; Hunt's approach is more painterly. Linnell, Hunt and Mulready all use muted palette when painting in oil; indeed, Sir George Beaumont criticised Linnell's work as "muddy' (see p.x above).

Lent from a Linnell private collection

2 Eel Pie House, Twickenham – Study from Nature

Oil on board. 16.5 × 25.5 cm
Signed and dated, *verso*, 'J. Linnell 1806'
COLLECTIONS: By descent from James Linnell to the present owner
EXHIBITION: Reigate, 1963, no. 31

Compared with cat. no. 1, this oil uses a broader technique which recalls the watercolour landscape studies made by Benjamin West (1738–1820) in the 1790s (e.g. *Landscape with Cottage and Boys in a Field* and *Landscape with Shepherd and Sheep*, Victoria & Albert Museum, nos. 56–1899 and 55–1899). West was probably Linnell's earliest tutor, correcting his drawings from the cast and encouraging him to sketch from nature. Throughout his life Linnell remained a great admirer of West's landscapes in oil. Linnell wrote in his 'Autobiographical Notes' of a *View of Hammersmith Terrace* (now untraced) that it was 'a sweet Claude-like view of the effect of sun and water with barges and boats and trees mingled. Painted with a firm delicate hand with great love of nature and of that particular spot.'

Lent from a Linnell private collection

3 Study of Buildings – Study from Nature

Oil on board. 16.5 × 25.5 cm
Signed and dated, *verso*, 'J. Linnell 1806'
COLLECTIONS: Purchased by the Tate Gallery, London, 1967 (T.935)
EXHIBITIONS: Norwich, Castle Museum, and London, Victoria & Albert Museum, *A Decade of British Naturalism, 1810–1820*, 1969–70, no. 30; Cambridge, Fitzwilliam Museum, and London, Royal Academy (Arts Council of Great Britain), *Painting from Nature*, 1980–1, no. 73
LITERATURE: Heleniak, *William Mulready*, p. 45

These studies were probably done at Twickenham, where John Varley took a house in the summer for the purpose of making studies from nature.

The detailed treatment of the surface of the building recalls those qualities in nature – abrupt changes in texture, intricacy of surface, mellow colouring – that had been defined by Sir Uvedale Price as 'picturesque'. This is confirmed in J. J. Jenkins's account of the working methods of Mulready, Linnell and William Hunt, published in J. L. Roget, *A History of the Old Water-Colour Society*, 2 vols. (London, 1891). They would 'sit down before any common object, the paling of a cottage garden or an old post, [and] try to imitate it minutely'.

The study was included, without the least alteration, in Linnell's oil painting of a cow yard (1831) (Victoria & Albert Museum, FA 134 – *Milking Time*). This use, some twenty-five years later, of a sketch done when the artist was aged fourteen gives some indication of the value Linnell must have set on these early studies.

Lent by the Trustees of the Tate Gallery

4 Twickenham – Study from Nature

Oil on board. 15.7 × 29.9 cm
Signed and dated, *verso*, 'J. Linnell 1806'
COLLECTIONS: By descent from the artist to the present owner
EXHIBITIONS: London, Colnaghi, 1973, no. 3, repr. pl. II; Tate Gallery, *Landscape in Britain c. 1750–1850*, 1973–4, no. 242

The most important aspect of Linnell's choice of landscape subjects before 1811 is that they are invariably small-scale, close-up views – a very Dutch concern with, to quote Fuseli, 'the meanest things in nature'. Here the broken fence and the sense of a small backwater off the River Thames recall the domestic scale of seventeenth-century Dutch landscape.

Lent anonymously

5 Back Kitchen at No. 2 Streatham Street, Bloomsbury

Pencil. 98 × 125 mm
Signed and dated in ink, lower left, 'J Linnell 1805–6'; inscribed in brown ink, upper left, 'Nº 2. Streatham St. Bloomsbury – back kitchen'

According to Linnell's 'Autobiographical Notes', the Linnell family moved to this address around 1800. Linnell writes: 'At first we lived chiefly in the Kitchen and Parlor [*sic*] and the first floor. The second floor was let – later however the whole floor was occupied by my father's business for he prospered here for some years through very bad times when bread was half a crown a loaf and press gangs roamed the streets.'

Lent anonymously

6 Three drawings of workmen in Russell Square

Black chalk with white highlights and pencil on blue paper. Each 120 × 150 mm, mounted on one card
(a) Inscribed and signed, in ink, lower left, 'Russell Square 1806 – J Linnell'. (b) Inscribed, signed and dated in ink, lower right, 'Russell Square / J. Linnell 1806'. (c) Signed, inscribed and dated in ink, lower right, 'J Linnell Russell Sqr 1806'
COLLECTIONS: By descent from the artist to the present owner
EXHIBITION: London, Colnaghi, 1973, no. 13

A large number of similar rapid sketches of workmen survive. Drawn between 1804 and 1806, they record the excavations of the foundations for the present buildings in Russell Square, erected between 1800 and 1817 by James Burton. It must have been drawings of this type which Linnell showed Benjamin West, the President of the Royal Academy, during their weekly sessions in 1805, which elicited the comment that West seemed 'well pleased' with the drawings – apparently more so than with Linnell's attempts to draw from the cast.

Lent from a Linnell private collection

7 Hungerford Steps

Pencil. 120 × 132 mm
Signed in ink, lower left, 'J Linnell'; inscribed in ink, lower right, 'Hungerford 1806'
COLLECTIONS: By descent from James Linnell to the artist's granddaughter Mrs Edith Bell; from her to the present owner

The diversity of drawing styles used by Linnell between 1805 and 1808 shows the influences of those artists with whom he was in contact. The careful linear style of this sheet particularly recalls Cornelius Varley.

Lent anonymously

8 Covent Garden Market

Pencil. 65 × 115 mm (irregularly trimmed)
Inscribed, dated and signed in ink, below, 'Covent Garden Market 1806–7. J Linnell'

3

In the two drawings (cat. nos. 8 & 9) of Covent Garden we see Linnell's work before any notions of beauty or ideal form were grafted on to his outlook by the Royal Academy. There is, therefore, a great historical and topographical attraction in these subjects, though ultimately the artist's record of the shapes and outlines of the stall – his attention to the particularity of the object – is the most memorable aspect of the drawings.

Lent anonymously

9 Covent Garden

Black chalk heightened with white chalk on grey paper. 135 × 180 mm
Inscribed, dated and signed in ink, lower left, 'Covent Garden Market 1806–7 J Linnell'
COLLECTIONS: By descent from James Linnell to the artist's granddaughter Mrs Edith Bell; from her to the present owner

See the preceding catalogue entry.

Lent anonymously

10 Landscape with Three Windmills

Pencil and black and white chalks on grey paper. 225 × 380 mm
Signed and dated in pencil, lower right, 'J Linnell 1806–7'
COLLECTIONS: By descent to the artist's granddaughter Mrs Edith Bell; from her to the present owner

The scene is probably Hampstead Heath, where Linnell is known to have sketched with Mulready in 1806. Three small paintings by Mulready in oil on millboard, done on the spot at Hampstead in that year, are in the Victoria & Albert Museum (FA 155, FA 153, FA 161). The windmill was to be an important motif in Linnell's oil paintings, the most notable of which is the Vernon picture, *The Windmill* of 1844, now in the Tate Gallery (439).

Lent anonymously

11 Fields Where Gower Street Now Stands, Bedford Square

Pencil and white chalk on blue paper. 162 × 225 mm (irregularly trimmed)
Dated, inscribed and signed in ink, lower right, '1808 Early. JL'. Inscribed in ink, lower left, 'Fields where / Gower st. now stands / Bedford Squ.' and in pencil, lower left, 'Gower Street field'
Verso: slight study of clouds (in pencil and chalk)

COLLECTIONS: By descent to Mrs J. M. Lees, a great-granddaughter of the artist; acquired by the British Museum, 1967 (BM 1967–12–9–4)

This drawing is mounted on the same card as cat. no. 12.

Lent by the Trustees of the British Museum

12 The Ruins in Wells Street, 1815

Pencil. 112 × 175 mm
Signed in brown ink, lower left, 'J. Linnell'; inscribed in pencil, below, 'View of the Ruins in Wells Street Rosemary Lane on Saturday Morg. Novr. 18. 1815.'
COLLECTIONS: By descent to Mrs J. M. Lees, a great-granddaughter of the artist; acquired by the British Museum, 1967 (BM 1967–12–9–5)

In the first ten years or so of his working life, from 1804 to 1815, Linnell's primary stimulus was visual. Reportage of everyday appearances in the city of London recurs throughout this period. These sketches appear to have been made solely for his own interest or record, and not to have been worked up into his oil paintings.

Lent by the Trustees of the British Museum

13 Cloud Studies

(a) Pen and ink with black chalk, brown and grey wash, heightened with white on grey paper. 261 × 278 mm
Signed and dated in brown ink, lower right, 'J Linnell 1811'
(b) Watercolour over pencil. 161 × 233 mm
Signed in brown ink, lower right, 'J. Linnell'
Verso: in watercolour over pencil, study of a mother and child
COLLECTIONS: By descent from William Linnell to the present owner
EXHIBITION: London, Colnaghi, 1973, nos. 52, 53

In 1811 Linnell's interest in natural phenomena and his investigation into the realism of natural appearances resulted in cloud studies such as these. It is noteworthy that it was the 'scientifically' minded Cornelius Varley who provided Linnell's introduction to the Baptist group, and it was on a visit to Cornelius Varley in September 1811 that Linnell made drawings of a comet (British Museum, Sketchbook, BM 1967–12–9–3).

Lent anonymously

14 Primrose Hill

Pen and brown ink with brown and grey wash, heightened with white chalk. 395 × 678 mm
Inscribed, signed and dated in ink, below, 'Primrose Hill. J Linnell 1811.'; inscribed in ink, lower right, 'part of primrose hill'

COLLECTIONS: By descent to Mrs J. Lucas, a great-great-granddaughter of the artist; sold Christie's, 3 March 1970, lot 56; with Colnaghi, 1970, from whom purchased by the Fitzwilliam Museum (Fairhaven Funds) (PD. 16–1970).
EXHIBITIONS: London, Colnaghi, *Exhibition of Old Master and English Drawings*, 1970, no. 132, and 1973, no. 17, repr. pl. V; Tate Gallery, *Landscape in Britain c. 1750–1850*, 1973–4, no. 243.

Although this drawing was executed long before Linnell met Blake or Palmer, it has in common with their work an almost hallucinatory intensity, created here by relentless sharpness of focus on the foliage on the surface and the sense of pulsating form beneath. Linnell's approach is reminiscent of Samuel Palmer's later description of attempting to draw the Elgin marbles and his 'sedulous efforts to render the marbles exactly, even to the granulation' (G. Grigson, *Samuel Palmer: The Visionary Years* (London, 1947), p. 12). Linnell's earlier interest in picturesque imagery had led him to concentrate on very small areas of landscape, but this drawing seems the antithesis of the Picturesque; Linnell's concentration on a featureless piece of hillside shows that it is the realism of the subject which is of fundamental importance to him. Palmer later wrote that Mulready's advice was to 'copy objects which were not beautiful, to cut away the adventitious aid of association' (*ibid.* p. 13). *Primrose Hill* is a good example of the unbeautiful transformed through the artist's concentration of vision. Linnell may have encountered in Sir Thomas Lawrence's collection a drawing, then attributed to Claude, by Angeluccio (active 1645–50) (Fitzwilliam Museum, PD.27–1958) which concentrates on the foliage of a hillside which could have provided him with a precedent for this sort of study.

Lent by the Fitzwilliam Museum, Cambridge

15 Bayswater

Watercolour over black chalk heightened with white on blue-grey paper. 221 × 534 mm
Inscribed and dated in ink, lower right, 'Bayswater 1811'
COLLECTIONS: By descent from the artist to the present owner
EXHIBITION: London, Colnaghi, 1973, no. 13
LITERATURE: R. Cork, *Evening Standard*, 3 Feb. 1973; C. Tisdall, *The Guardian*, 11 Feb. 1973

By 1811 Linnell was living and working in the Edgware Road/Bayswater area. A noticeable feature of his drawings of this year, and one particularly evident in this one of Bayswater, is their much greater sense of form.

Lent anonymously

16 Corner of the reservoir to Steam Engine Water Works, Cambridge Terrace

Watercolour over pencil. 339 × 538 mm
Signed and dated in ink, lower right, 'J. Linnell 1816'; inscribed in pencil, ? by the artist,

probably at a later date, 'Corner of reservoir to Steam Engine / Water Works – Cambridge Terrace' and, upper right, '94'
COLLECTIONS: Sir Bruce Ingram; Ashmolean Museum, Oxford (Virtue–Tebbs Bequest Purchase, 1963)
EXHIBITIONS: Oxford, Ashmolean Museum, *Exhibition of English Drawings Purchased from the Collection of Sir Bruce Ingram*, 1963, no. 54; London, Colnaghi, 1973, no. 20

Christiana Knowles has suggested orally to the author that the accepted date of 1816 for this drawing is a misreading of '1811'. The delicate watercolour and the relatively insubstantial way in which volume has been handled tend to confirm the earlier date. The sheet may be compared with Linnell's watercolours of the brick kiln and Kensington Gardens (cat. nos. 18–21). They too record London suburbs, whereas among the dated landscape drawings executed between 1813 and 1818 none is of a London location. There is a related drawing in the Yale Center for British Art (no. B 1975.4.1563), undated and inscribed 'near the Steam Engine, Cambridge Terrace'. Cambridge Terrace, near Regent's Park, was built between 1805 and 1825.

Lent by the Visitors of the Ashmolean Museum, Oxford

17 The East Side of the Edgware Road, looking towards Kensington Gardens

Oil on board. 36.8 × 38.8 cm
Inscribed, *verso*, 'A view from my window the east side of the Edgeware Road looking towards Kensington Gardens, Mid-day. Painted from Nature about 1812.'
COLLECTIONS: Miss M. Rathbone, by whom presented to Leighton House, 1961 (no. 102)
EXHIBITIONS: Cambridge, Fitzwilliam Museum, and London, Royal Academy (Arts Council of Great Britain), *Painting from Nature*, 1980–1, no. 74
LITERATURE: A. T. Story, *The Life of John Linnell* (2 vols., London, 1893), II, p. 260

Between 1809 and 1811 Linnell lived partly with his father at Streatham Street and partly at Mulready's house in Kensington Gravel Pits. In 1811 he took a second-floor flat at No. 11 Queen Street, Edgware Road, at a rent of £20 a year, sharing the house with a Captain Strutt. The Queen Street address is given with Linnell's entries to the British Institution for 1812 and 1813, and it was most probably the view from an upper floor of this house which Linnell used as the subject of the painting. At this date the Edgware Road had houses on the east side only. The view is therefore from the east side of the Edgware Road and looks across rural Bayswater to Kensington Gardens. Although not strictly speaking a painting *en plein air*, it is done direct from nature, and, according to Story, was retouched much later, in 1865. It recalls Constable's pictures *Golding Constable's Kitchen Garden* and *Flower Garden* of 1815, both painted from an upper-floor window with great attention to local colour. Linnell continued to paint in oil direct from nature on occasions after this, see cat. no. 51.

Lent by The Royal Borough of Kensington & Chelsea, Libraries & Arts Service, Leighton House Art Gallery & Museum, London

18–21 Kensington – Four Studies: three of a brick kiln and one of Kensington Gardens

Watercolour. Each approximately 103 × 144 mm

Nos. 18–19 signed and dated in ink, lower right, 'J. Linnell 1812'. No. 20 signed in ink, lower left, 'J L.' and dated, lower right, '1812'. No. 21 signed, dated and inscribed in ink, lower left, 'J Linnell 1812 Kensington [Gardens?] about 1812' (part cut off)

COLLECTIONS: By descent from the artist to the present owner

EXHIBITIONS: London, Royal Academy, 1883, no. 143; Colnaghi, 1973, no. 19b–e; Tate Gallery, *Landscape in Britain c. 1750–1850*, 1973–4, no. 244b–e; Hamburg, Kunsthalle, *William Turner und die Landschaft seiner Zeit*, 1976, nos. 302, 277, 303, 304; Salisbury, Festival Exhibition, 1977, no. 17b–e; New York, Museum of Modern Art, *Before Photography: Painting and the Invention of Photography*, 1981, no. 30a–c illus. pp. 56–7

These studies were presumably done while Linnell was lodging with Mulready in Kensington. The brick kiln was on the east side of Church Lane (now Church Street), Kensington. The three studies are remarkable for their early date as examples of an artist studying the same object under different light effects and from different points of view, experimenting with extreme asymmetry in one composition and with balance in another.

Lent anonymously

22 Kensington Gravel Pits

Illustrated in colour

Oil on canvas. 70 × 105 cm

Signed, lower left, 'J. Linnell.'

COLLECTIONS: Sold at the Liverpool Academy, 1813, 'to a gentleman'; Mr McKay; sold by him, 1847, to T. Creswick, who resold in the same year to the dealer Rougut; G. T. Andrews of York; his sale, Christie's, 31 May 1851, lot 100, bought Thos Agnew & Sons; T. Horrocks Miller by 1857; Pitt-Rivers; Leggatt Bros, from whom purchased by the Tate Gallery (Grant-in-Aid), 1947 (no. 5776)

EXHIBITIONS: London, British Institution, 1813, no. 99; Liverpool Academy, 1813, no. 73; London, Royal Academy, *Winter Exhibition of Old Masters*, 1889, no. 44; Colnaghi, 1973, no. 18; Tate Gallery, *Landscape in Britain c. 1750–1850*, 1973–4, no. 245

LITERATURE: K. Pasmire, 'When Gravel Was Dug in Kensington', *Country Life*, 183, no. 4089 (13 Nov. 1975), 1335–6

In the early nineteenth century, the area of Notting Hill around the Bayswater Road and Church Street, Kensington, was known as Kensington Gravel Pits. It took its name from the gravel quarries adjoining Kensington Gardens. The area was then a rural village outside London, and was a popular area for artists such as A. W. Callcott and Thomas Webster. Mulready and Linnell shared lodgings in the Mall. Linnell wrote of this period: 'I went every evening nearly all the season to the Royal Academy to draw with Mulready.' Drawing from the life at the Academy undoubtedly influenced Linnell's treatment of the figures in the composition. The same pose appears three times. Clear too is the influence of High Renaissance models. The painting owes as much to Linnell's study of Michelangelo and Raphael as it does to the direct observation of figures and landscape. It is instructive to contrast this picture with Mulready's two small oils

of the Mall, Kensington, *The Mall* and *Near the Mall*, done in 1811–12, now at the Victoria & Albert Museum (FA 136 and FA 135), in which Mulready concentrates on the genre aspects of the rural village. Having failed to find a buyer for the picture at the 1813 exhibition of the British Institution, Linnell, as was his wont, dispatched the landscape to try a provincial market, in this case Liverpool. There, the sale of the picture to an unknown gentleman was arranged by the Secretary of the Liverpool Academy, Henry Hole, the pupil of Thomas Bewick.

Lent by the Trustees of the Tate Gallery

23 Dolwyddelan Valley, North Wales

Watercolour over traces of pencil outline. 191 × 50 mm
Signed, dated and inscribed in ink, lower left, 'J Linnell 1813 . N. Wales.' and, lower right, 'DollyDellan Valley'
COLLECTIONS: By descent from the artist to the present owner
EXHIBITIONS: London, Colnaghi, 1973, no. 27, repr. pl. x; Salisbury, Festival Exhibition, 1977, no. 2

Linnell's visit to North Wales in 1813 was the first, and perhaps the most important, of his sketching tours. His fellow traveller was G. R. Lewis (1782–1871), a member of the former Sketching Society, who in 1812 had engraved drawings by Michelangelo as illustrations for William Young Ottley's *Italian Schools of Design*. Linnell's choice of companion is indicative of his concern at this date to marry High Renaissance principles of form with his perception of landscape. The entire Welsh tour seems to have been spent in a mood of heightened sensibility, perhaps provoked by the travellers' fasting and observance of 'a strict, semi-mosaic code of diet'. In Wales, Linnell finally abandoned, at least in his studies, any further interest in the picturesque mode of landscape. He wrote that 'The Varley School of Welsh landscape I found to be conventional and the refuge of those who had no powers in figure drawing or individualisation ... I then saw that elaborate drawing which was only to be acquired by drawing the naked figure was essential in everything – in trees and rocks as much as the figure itself and that it was their quality which I felt to be so entirely the source of all that I admired in the works of the great men of Italy and Germany' ('Autobiographical Notes', p. 46). Linnell's studies made on the tour range from the meticulous linear elegance of the Dolbadern drawing (cat. no. 26) to the free watercolour sketches (cat. nos. 24, 27) in which colour is applied without underdrawing, and focus and detail are achieved almost entirely by juxtaposing different scales of brushmark.

Lent anonymously

24 North Wales

Watercolour. 236 × 370 mm (irregularly trimmed)
Inscribed, signed and dated in ink, lower left, 'N. Wales J Linnell 1813.'; inscribed in pencil, upper right, 'clouds warm.'

See the preceding entry.

Lent anonymously

25 Near Dolwyddelan, North Wales

Watercolour over traces of pencil outline. 242 × 387 mm
Inscribed, signed and dated in ink, lower left, 'Nr Dollydellan N Wales – J Linnell 1813 Eagles seen here.'
COLLECTIONS: By descent from the artist to the present owner
EXHIBITIONS: London, Colnaghi, 1973, no. 28; Salisbury, Festival Exhibition, 1977, no. 3

See the entry for cat. no. 23.

Lent anonymously

26 Landscape, North Wales, Dolbadern

Pen, ink and watercolour over pencil, heightened with white chalk on grey paper. 458 × 580 mm
Signed and inscribed in brown ink, below, 'J. Linnell N. Wales. Dolbadern'
COLLECTIONS: With Colnaghi, 1972; bought by the present owner
EXHIBITIONS: London, Colnaghi, *English Watercolours and Drawings*, 1972, no. 122, and 1973, no. 22

See the entry for cat. no. 23.

Lent anonymously

27 Haymaking, North Wales

Watercolour. 228 × 364 mm
Inscribed, signed and dated in ink, lower left, 'N W. J Linnell 1813'
COLLECTION: Sir John and Lady Witt (no. 1917)

This drawing is one of the studies used by Linnell for his oil painting *The Haymaker's Repast* (cat. no. 28)

Lent by Sir John and Lady Witt

28 The Haymaker's Repast: A scene in Wales

Oil on panel. 39.3 × 72.5 cm
Signed and dated, 1815

COLLECTIONS: Mr Lopez; Mr Thomson; Mr Peacock; Mr Rought (during the 1850s); with Spink & Co., 1973; bought by the present owner
EXHIBITIONS: London, Society of Painters in Oil and Water-Colours, 1815, no. 152
LITERATURE: Story, *Linnell*, II, p. 261

In this painting Linnell used studies he had made over a year earlier when touring Wales (see cat. no. 27). He continued throughout his life to adapt sketches made on his Welsh visit of 1813 into formally arranged compositions as the basis of finished pictures.

Lent anonymously

29 Alpha Cottages

Watercolour. 103 × 145 mm
Inscribed, signed and dated in ink, lower right, 'Alpha Cott—J Linnell 1814'
COLLECTIONS: By descent from the artist to the present owner
EXHIBITIONS: London, Royal Academy, 1883, no. 143; Colnaghi, 1973, no. 19a, repr. pl. VIIa; Tate Gallery, *Landscape in Britain c. 1750–1850*, 1973–4, no. 244a; Hamburg, Kunsthalle, *William Turner und die Landschaft seiner Zeit*, 1976, no. 250, repr. p. 268; Salisbury, Festival Exhibition, 1977, no. 17a

Alpha Cottages were designed by the architect Charles Heathcote Tatham (the father of Frederick Tatham), whom Linnell knew through the Baptist group at Keppel Street. The curious flatness of the building in the foreground and abrupt changes in scale and tone suggest the use of an optical drawing instrument, probably a Graphic Telescope. This was patented by Cornelius Varley on 4 June 1811 and came equipped with a stand or table on which the artist's paper lay, and on which he saw reflected the image before him. It can be assumed, therefore, that the artist saw not only the outlines of the landscape, but its tonal areas if not its colours reflected on the paper. The instrument seems to have been designed primarily for drawing landscapes, and Cornelius Varley's drawing *View from Ferry Bridge, Yorkshire* (British Museum 1886–10–12–564) shows its use for this purpose. Its focus could be altered, and although it was intended to facilitate drawing distant objects, it must presumably also have encompassed those which were near at hand, perhaps giving them a greater distortion, as here.

Lent anonymously

30 Pike Pool on the River Dove, Dovedale

Illustrated in colour
Pen, ink and watercolour. 220 × 250 mm
Signed and dated in brown ink, lower left, 'J. Linnell. / 1814.'; inscribed in pencil, below, 'Pike Pool'
COLLECTIONS: Samuel Bagster; J. P. Heseltine (Lugt 1508); Beryl Kendall; with the Albany Gallery; with Colnaghi, 1969, from whom purchased by the Fitzwilliam Museum, Cambridge (Fairhaven Fund) (PD.14–1969)

EXHIBITIONS: London, Colnaghi, *Exhibition of Old Master and English Drawings*, 1969, no. 97, and 1973, no. 31
LITERATURE: Linnell MSS., 'Cash Account Books'; *John Varley and his Pupils: Original Drawings in the Collection of J.P.H.[eseltine]* (London, 1918), no. 6, pl. 6; G. Grigson, *Britain Observed* (London, 1975), fig. 72
ENGRAVED: By Grieg in I. Walton and C. Cotton, *The Compleat Angler* (London, 1815), p. 129

In the summer of 1814 Linnell was commissioned by the Baptist publisher Samuel Bagster to provide some of the illustrations for a forthcoming edition of Walton and Cotton's *Compleat Angler*. Bagster travelled with Linnell on the sketching tour as far as Beresford Hall ('Autobiographical Notes', p. 48). By 1815 Bagster had bought of Linnell not only the illustrations he required, but most of the work done on the tour, apart from the River Lea drawings. The pen outlines of *Pike Pool* and *Mouse Bridge* (cat. no. 33) were presumably to aid the engraver, since it does not seem to have been Linnell's practice before or after 1814 to use watercolour in this way. In 1825 Thomas Stothard was commissioned to provide drawings of the locations used in *The Compleat Angler*, and, whether by choice or by commission, his view called *Pike Pool* closely follows Linnell's composition.

Lent by the Fitzwilliam Museum, Cambridge

31 Dovedale, Derbyshire

Watercolour over black chalk heightened with white chalk. 323 × 527 mm
Signed, dated and inscribed in brown ink, below, 'J. Linnell. 1814 – Dove-dale Derbyshire'
COLLECTIONS: By descent from the artist to the present owner
EXHIBITIONS: London, Colnaghi, 1973, no. 32, repr. pl. XII; Salisbury, Festival Exhibition, 1877, no. 11

See the preceding catalogue entry. This view, however, was not engraved.

Lent anonymously

32 In Dovedale

Oil on panel. 22.75 × 17.25 cm
Signed, lower right, 'J Linnell'
COLLECTIONS: Samuel Bagster; Ralph Edwards, Esq., C.B.E.; with Gooden & Fox, Ltd, 1963; Mr and Mrs Paul Mellon (no. 623); Yale Center for British Art, Paul Mellon Collection (no. 623)
EXHIBITION: Richmond, Va., Museum of Fine Arts, *Painting in England 1700–1850: The Collection of Mr and Mrs Paul Mellon*, 1963, no. 158
LITERATURE: Linnell MSS., 'Cash Account Books'

According to Linnell's cash book, this picture was delivered to Samuel Bagster in the same month, March 1815, as the drawing for *Pike Pool*.

Lent by the Yale Center for British Art, Paul Mellon Collection

33 Mouse Bridge at the Foot of Hanson Toot, Derbyshire

Pen and brown ink and watercolour. 153 irregular × 226 mm (an old repair upper right)
Inscribed on mount, not in Linnell's hand, 'Mouse Bridge, foot of Hanson Toot by Linnell'
COLLECTIONS: Samuel Bagster, 1815; Mrs W. W. Spooner, who presented it to Sir John
and Lady Witt (no. 1364)

Mouse Bridge, in Dovedale, was on Linnell's itinerary when he visited the area
with Samuel Bagster in 1814. The drawing was completed and finally sold to
Bagster in March 1815 for £1. 11s. 6d. Like the *Pike Pool* drawing (cat. no. 30),
there is a firmness to the drawing provided by the strong outlines in ink. This
technique may have been employed by Linnell in order to facilitate the transfer of
the drawing to the engraving plate.

Lent by Sir John and Lady Witt

34 The Valley of the River Lea, Hertfordshire

Watercolour and black chalk heightened with white on blue paper. 340 × 540 mm
Inscribed, signed and dated in ink, lower right, 'River Lea. J Linnell 1814'; inscribed,
possibly with colour note, upper right, in cipher
COLLECTIONS: By descent to Mrs Edith Bell, granddaughter of the artist; Sotheby's, 30
Nov. 1978, lot 5, bought Colnaghi; British Museum (1980-1-26-116)

Linnell's visits to the River Lea in Hertfordshire were made, according to his
'Journals', in early 1814, in connection with the commission for illustrations to
The Compleat Angler (see cat. no. 30). However, the bills and receipts from
Bagster to the artist make no mention of his drawings of the River Lea, and they
remained in the artist's collection at his death.

Lent by the Trustees of the British Museum

35 River Kennet, near Newbury

Watercolour over pencil. 161 × 234 mm
Inscribed, signed and dated in brown ink, lower left, 'River Kennett J Linnell 1815'
COLLECTIONS: By descent from the artist to the present owner
EXHIBITIONS: On loan to the Ashmolean Museum, Oxford, 1970-1; London, Colnaghi,
1973, no. 41, repr. pl. XVII; Munich, Haus der Kunst, *Zwei Jahrhunderte englische Malerei*,
1979-80, no. 288, repr.

This drawing is a study for cat. no. 36.

Lent anonymously

36 The River Kennet, near Newbury

Illustrated in colour
Oil on canvas on wood. 45.1 × 65.2 cm
Damaged signature and date, lower left, '... innell 18[?]5' (the '5' conjectural)

COLLECTIONS: Mr Blackie, 1831; bought Ralph Thomas, 1845; his sale, Phillips, 2 May 1848, lot 81; with Thos Agnew & Sons, 1868; Arthur W. Lyon by 1870; sold by order of his executors, Christie's, 19 May 1883, lot 100, bought Tooth; J. W. Adamson; his sale, Christie's, 7 May 1887, lot 122; Col. M. H. Grant by *c.* 1933; with Colnaghi, 1958, from whom purchased by the Fitzwilliam Museum (Fairhaven Fund), 1958 (PD.55–1958)
EXHIBITIONS: London, Society of Painters in Oil and Water-Colours, *12th Exhibition*, 1816, no 13; British Institution, 1826, no. 138; Derby, *Works of Art and Industrial Products*, 1870, no. 33 (lent by A. W. Lyon); London, Arts Council of Great Britain, *Early English Landscapes from Colonel Grant's Collection*, 1952–3, no. 34; Colnaghi, *Paintings by Old Masters*, 1958, no. 17, and 1973, no. 40
LITERATURE: Story, *Linnell*, II, p. 261; Fitzwilliam Museum, Cambridge, *Catalogue of Paintings,* vol. III, *British School*, by J. W. Goodison (Cambridge, 1977), pp. 156–7, repr. pl. 37; W. Vaughan, *Romantic Art* (London, 1978), p. 215

In Colonel Grant's collection, the painting was called *The Newbury Canal.* Its close connection with the watercolour inscribed 'River Kennett' and dated 1815 (cat. no. 35) established both the location and the correct reading of the date. This painting must be the one referred to by Story (*op. cit.*) as '*View on the River Kennet' (near Newbury), 1815.* During the summer of that year, Linnell was at Newbury painting portraits. As J. W. Goodison pointed out in his catalogue, the inclusion of the barge identified the scene as the stretch of the Kennet between Newbury and Reading which was made navigable in 1714.

In the 'Landscape Sketchbook' Linnell noted that he had retouched the painting, *gratis*, for Agnew in 1868.

Lent by the Fitzwilliam Museum, Cambridge

37 Donnington Castle, near Newbury

Watercolour over pencil. 218 × 165 mm
Signed in brown ink, lower right, 'J Linnell'; inscribed in pencil, lower left, 'Donnington Castle nʳ Newbury'
COLLECTIONS: By descent from the artist to the present owner
EXHIBITIONS: London, Colnaghi, 1973, no. 42; Salisbury, Festival Exhibition, 1977, no. 9

Linnell travelled through Newbury on his sketching tour of 1815. Uncharacteristically, there is no further use made of this study, perhaps because of its unusual viewpoint.

Lent anonymously

38 Windsor Park

Coloured chalks and bodycolour over black chalk with traces of oil. 344 irregular by 534 mm
COLLECTIONS: L. G. Duke; Sir John and Lady Witt (no. 605)

In May 1815, Linnell spent about a month at the village of Winkfield near Windsor, which he used as a base for his sketching trips to Windsor Forest. The

presence of his fiancée, Mary Ann Palmer, on the tour must have provided an added incentive, for Linnell produced a great number of studies of the forest and of the working life of the men within it. Cat. nos. 38 and 39 are unusual among Linnell's drawings of this period, as they concentrate on a complete scene, not on the meticulous recording of individual appearances. There is another drawing of the same foreground and group of trees which is clearly preparatory to this and more detailed (formerly in the L. G. Duke Collection).

Lent by Sir John and Lady Witt

39 Cottage at Windsor Great Park

Black chalk, bodycolour and coloured chalks with traces of watercolour. 365 irregular × 485 mm
COLLECTIONS: L. G. Duke; Sir John and Lady Witt (no. 604)

Presumably drawn in 1815; see the preceding entry.

Lent by Sir John and Lady Witt

40 Windsor Forest

Oil on paper laid down on panel; retouched April 1824. 64.8 × 23.7 cm
Signed, lower left, 'J. Linnell. F'
COLLECTIONS: Mr Robson, 1831; with Colnaghi, *c.* 1975; sold Christie's, 23 Nov. 1979, lot 144, bought by the present owner
EXHIBITIONS: London, Society of Painters in Oil and Water-Colours, 1819 (*A Forest Scene*); British Institution, 1823 (*View in Bragwood, Windsor Forest*); Manchester Academy, 1830

Linnell's 'Journal' records the picture being painted in 1818–19. It was further retouched in April 1824, in December 1829 and finally in June 1830. Like the earlier *Kensington Gravel Pits* (cat. no. 22), the painting combines a heroic view of men and landscape with direct observation. Comparison with a painting of Windsor Forest of 1863 (cat. no. 97) shows how far Linnell's later interest veered towards a more sentimental view of nature.

Lent anonymously

41 Culver Cliff, Isle of Wight

Watercolour. 147 × 385 mm
Inscribed, signed and dated in brown ink, lower left, 'Culver Cliff / Isle of Wight 1815. J. Linnell'
COLLECTIONS: By descent from the artist; acquired by the British Museum, 1967 (1967–12–9–2)

September 1815 saw Linnell in Southampton and the Isle of Wight, on a walking

tour of the island. A passage from his 'Autobiographical Notes' is particularly apposite:

> I remember walking from Newport to Niton and being exceedingly delighted by a sudden view of the sea from the summit of the hill I had gradually ascended. It was a splendid day and the view northwards made me think of Xenophon's account of the ten thousand. Nothing of the kind before or since was equal to that moment when I caught sight of that high horizon of light blue sea with the mid-day sun shining into it. Oh how vast, how infinite it seemed to me, I cried out in ecstacy though alone.

Many of the studies Linnell made in Southampton and the Isle of Wight share the wide-angle lens effect of this drawing. The natural topography of the area lends itself to this approach, and this may have inspired Linnell to emulate Girtin, whom he revered as the greatest master of watercolour. It should be noted, however, that panoramic views were popular at this period – compare Turner's *Rosehill Park* (Fitzwilliam Museum, PD.19–1979) and De Wint's *Cliveden on Thames* (Fitzwilliam Museum, PD. 130–1950).

Lent by the Trustees of the British Museum

42 Steep Hill, Isle of Wight

Oil on millboard. 19.7 × 35.0 cm
Signed, lower left, 'J. Linnell'
COLLECTIONS: Mr Vine; Mr Steedman; private collection
EXHIBITIONS: London, Society of Painters in Oil and Water-Colours, 1816; Colnaghi, 1973, no. 58

Linnell's visit to the Isle of Wight in 1815 was, as he reported back to his father, 'a pleasant and (I think for the time) not unprofitable tour round the most Picturesque part'. While there he completed a large drawing of Bonchurch, which is a study for this painting and which is now in the collection of the Minneapolis Institute of Art (68.53.4). Linnell completed the painting on his return to London in late 1815 and early 1816, finishing it in time for the Spring Gardens exhibition of that year, where it was sold for seven guineas. Linnell painted a duplicate in 1826 to which the drawing in the British Museum sketchbook of 1819 (1967–12–9–3, fol. 18) is presumably related, which was sold at Christie's on 13 October 1978 (lot 165, as *A Homestead*) and is now in the Boston Museum of Fine Arts (23.1979).

Lent anonymously

43 Forest Scene with Bark Renders

Oil on millboard. 25.0 × 17.5 cm
Signed and dated, lower right, 'J L. 1816'

COLLECTIONS: Mr Vine, 1816; Hubert Martineau, 1883; Mr and Mrs Paul Mellon; Yale Center for British Art, Paul Mellon Collection (B 1975.4.1327)
EXHIBITIONS: London, Society of Painters in Oil and Water-Colours, 1816; Royal Academy, 1883, no. 29

Linnell's 'Autobiographical Notes' (p. 51) record that in 1816 the artist went to Sevenoaks in Kent 'on purpose to make studies for falling timbers'. It seems likely that this painting, with its strong sense of daylight and quality of freshness, may have been painted from nature on this visit.

Lent by the Yale Center for British Art, Paul Mellon Collection

44 Tythrop

Watercolour over pencil and black chalk heightened with white chalk on grey paper. 443 × 287 mm
Signed, inscribed and dated in brown ink, lower right, 'J Linnell Tythrop 1817'
COLLECTIONS: By descent from the artist to Miss Joan Ivimy, from whom purchased by the Fitzwilliam Museum (Biffen Fund), 1957 (PD.4–1957)
EXHIBITION: London, Colnaghi, 1973, no. 51

This is one of many tree studies drawn while Linnell stayed at Tythrop House, Thame in Oxfordshire, where he was painting portraits of the Wykeham family. (See cat. no. 73)

Lent by the Fitzwilliam Museum, Cambridge

45 Coast Scene at Cullercoats

Watercolour over pencil. 249 × 322 mm
Inscribed with extensive colour notes
COLLECTIONS: Carl Bernard Milling; Sir John and Lady Witt (no. 854)

Linnell and his wife visited Cullercoats, on the Northumberland coast, on their journey homeward after their marriage and honeymoon in Scotland in 1817. This study is closely connected with the oil painting, cat. no. 46.

Lent by Sir John and Lady Witt

46 Coast Scene at Cullercoats, near Whitley Bay

Oil on paper laid down on board. 21.5 × 36.7 cm
COLLECTIONS: With Gooden & Fox, Ltd, 1969; Mr and Mrs Paul Mellon; Yale Center for British Art, Paul Mellon Collection (no. 1404)

See the preceding entry. This sketch and others of Cullercoats in a private collection are unusual in that the oils retain all the freshness and spontaneity of

Linnell's watercolour technique and, indeed, can be said to be more adventurous technically.

Lent by the Yale Center for British Art, Paul Mellon Collection

47 Coast Scene, Cullercoats

Coloured chalks over black chalk outline on grey paper with highlights in watercolour and oil. 230 × 310 mm
COLLECTION: Sir John and Lady Witt (no. 910)

See the entries for nos. 45 and 46.

Lent by Sir John and Lady Witt

48 Midday

Etching. 135 × 237.5 mm
Signed in the plate 'J. Linnell. fecit 1818.' and lettered 'published March 1818 by J. Linnell'
COLLECTIONS: By descent from the artist to the present owner

Etched and published in 1818, the year in which Linnell met Blake for the first time and studied with him in the British Museum, this is one of only two etchings of landscape by Linnell. Perhaps on the advice of George Cumberland senior, who had published a pamphlet on Bonasone, Blake and Linnell studied the work of this engraver; some of the delicate, linear style of the *Midday* etching may be attributed to his influence. There is a small oil by Linnell of the same subject, also done in 1818 (Royal Albert Memorial Museum, Exeter), and the subject was repeated in 1847 (private collection, U.S.A.).

Lent anonymously

49 Woodcutters' Repast

Etching. 143 × 242 mm
Signed in the plate 'J Linnell fecit 1818'
COLLECTIONS: By descent from the artist to the present owner

This etching is the reverse image of a signed drawing of the same subject done in 1815 (now in a private collection). Linnell also painted two versions in oil of the subject, one of which is dated 1820 and is in the Lady Lever Art Gallery, Port Sunlight (no. 142). The second version, a duplicate of the first, was painted for Thomas Webster, R.A. (1800–86) and is now in a private collection.

Lent anonymously

50 Twilight

Oil on board. 14 × 11 cm
COLLECTIONS: By descent from James Linnell to the present owner

Linnell's 'Journal' for March 1819 reads: '4th small picture of twilight 5 × 4 (tiny sketch showing trees and crescent moon. Upright and low horizon)'. This small oil must have been completed around the time of Linnell's first meeting with William Blake and three years before he met Samuel Palmer. The drawing is similar in technique to the work of Edward Calvert of the same period.

Lent from a Linnell private collection

51 East Window of Netley Abbey

Watercolour over pencil. 162 × 234 mm
Inscribed, signed and dated in brown ink, lower left, 'Netly Abbey East Window. J Linnell 1819'
COLLECTIONS: By descent from the artist to the present owner
EXHIBITION: London, Colnaghi, 1973, no. 56

The ruins of Netley Abbey provided Linnell, like many of his contemporaries, with ideal Romantic subject matter. He drew there in clear daylight, dusk and moonlight. The British Museum has a drawing in ink attributed to Linnell (1956–12–24–1) which was clearly intended to be viewed as a transparency, illuminated from behind. The suitability of the 'gothic' ruins of the Abbey for this sort of theatrical treatment was shown later, in 1826, when Daguerre staged a 'Peocilorama' (a type of diorama) of 'the rich tracery of the ruins of Netley Abbey, with its ivy and mossy mantled walls ... well seen by moonlight effect' (*Ackerman's Repository*, March 1826).

Linnell's own account is the evidence for a *plein air* painting in oils of the same date: 'went to Netly Abbey, and painted on the spot my large oil study of the interior. I spent 10 or 12 days upon it, leaving it at a farm every night.' This large oil, 99.0 × 124.5 cm, was in the possession of the Linnell family at the time of the artist's death, but since has not been traced.

Lent anonymously

52 Harrow from Hampstead Heath

Watercolour over pencil with black chalk heightened with white chalk on blue-grey paper. 276 × 139 mm
Signed and dated, below, 'J Linnell @ 1820'; inscribed in brown ink, lower right, 'Harrow from Hampstead H.'
Verso: a drawing in black chalk heightened with white: a study of the front of a house
COLLECTIONS: By descent from the artist to the present owner
EXHIBITIONS: London, Colnaghi, 1973, no. 59; Salisbury, Festival Exhibition, 1977, no. 8

As in *Culver Cliff* (cat. no. 41), Linnell has painted here a broad sweep of landscape. If the date, added later by himself, is correct, the drawing must have been done on an early visit to North Hampstead, before he went to live at Collins's Farm. Linnell often added a date to his work long after he had completed it. In the 1860s, largely for the benefit of his son James, he seems to have turned his attention to the documentation of his works. It was then, too, that he began his 'Liber Veritatis' (cat. no. 100a and b) and 'Autobiographical Notes'. The drawing should be compared with *Summer Evening, Boys Bathing, Harrow in the Distance* (cat. no. 91) painted in 1847, for which this sketch may have provided some material.

Lent anonymously

53 Garden of Collins's Farm, with Rainbow

Watercolour over pencil. 160 × 231 mm
Inscribed and dated in the artist's hand in brown ink, lower right, 'J Linnell's Garden Hampstead 1823'; inscribed, below, 'Collins Farm'
COLLECTIONS: By descent from the artist to the present owner
EXHIBITIONS: Colnaghi, 1973, no. 65, repr. pl. XXIII; Salisbury, Festival Exhibition, 1977, no. 7

Collins's Farm, later renamed Wyldes Farm, is a weatherboarded house in North End, on the east side of Hampstead Way. Linnell lived there from March 1824 until 1828, when he moved back to Bayswater. Charles Dickens lived there briefly, in 1837.

Lent anonymously

54 A Stormy Landscape – Hampstead Heath

Watercolour. 163 × 234 mm
Signed in brown ink, lower left, 'J Linnell'
COLLECTION: Sir John and Lady Witt (no. 814)
EXHIBITION: London, Courtauld Institute Galleries, *The Sir John Witt Collection, Part II: The English School*, 1963, no. 63

The scene is identified here as Hampstead Heath, probably done in the 1820s when Linnell was living at North End. It is interesting to note here the attention Linnell gives to the interrelationship of land and sky. This was also a preoccupation of John Constable, Linnell's neighbour at Hampstead in the early 1820s. Even though after their arguments over D. C. Read (see Story, *Linnell*, I, pp. 125ff) in 1819 relations between the two artists were very strained, it is clear that they were interested in the same things; indeed, later, Linnell was called upon to finish one of Constable's paintings left incomplete at his death in 1837.

Lent by Sir John and Lady Witt

55 Five Studies at North End, Hampstead

Pencil, mounted together, the largest 163 × 231 mm
Each inscribed in brown ink, lower left or lower right, 'North End Hampstead' and the last three sheets dated '1824'
COLLECTIONS: By descent from the artist to the present owner
EXHIBITION: London, Colnaghi, 1973, no. 60

These drawings are probably studies of Linnell's growing family made while they lived at Collins's Farm, North End, Hampstead. Judging by the date of three of the drawings, the sitters may be identified as follows: (a) Mrs Linnell, Hannah and John Linnell; (b) Elizabeth Linnell; (c) Mrs Linnell, John and Elizabeth Linnell; (d) John and Elizabeth Linnell. The fifth is a landscape sketch which contains no figures.

Lent anonymously

56 Hampstead

Ink and wash. 183 × 279 mm
Signed, inscribed and dated in ink, lower left, 'J Linnell – Hampstead / 25–6'
COLLECTIONS: By descent from the artist to the present owner

The drawing clearly shows the influence on Linnell of Palmer's Shoreham pen-and-ink drawings. Linnell's treatment of texture, however, is less clearly defined than Palmer's, and he does not entirely lose all sense of topography, for the scene is recognisable as Branch Hill Pond, Hampstead.

Lent anonymously

57 An Avenue of Trees at North End by Hampstead Heath

Watercolour over traces of 'lead' pencil. 162 × 277 mm
Inscribed, signed and dated in ink, lower right, 'Hampstead J Linnell 1826'
COLLECTIONS: With Nicholson, from whom bought by Sir John Witt; bequeathed by him to the Courtauld Institute Galleries, 1952 (Witt no. 3303)
EXHIBITION: London, Camden Arts Centre, *The Camden Scene*, 1979, no. 171, repr.

Lent by the Courtauld Institute Galleries, Witt Bequest

58 View of Collins's Farm, Hampstead

Oil on board. 15 × 22 cm
Signed, lower right, 'J. Linnell.'
COLLECTIONS: By descent from the artist to the present owner
EXHIBITION: London, Royal Academy, 1883, no. 18

This painting and cat. no. 60 were probably executed in 1827, when Linnell's

'Journal' contains several unspecific references to small oils 'upon panel of North End'.

Lent anonymously

59 Collins's Farm, North End, Hampstead

Oil on panel. 23.5 × 37.5 cm
Inscribed, *verso*, 'Collin[s's] Farm / North End / Hampstead Heath / painted by John Linnell sen^r 1831'
COLLECTIONS: With the Maas Gallery, London, from whom purchased by the Museum of London (Joicey Trust Fund), 1963 (63.62)
EXHIBITION: London, Camden Arts Centre, *The Camden Scene*, 1979, no. 173
LITERATURE: Linnell MSS., 'Journal', 1831; J. Hayes, *Catalogue of the Oil Paintings in the London Museum* (London (H.M.S.O.), 1970), p. 130, no. 69, repr. pl. 69

For a note on Collins's Farm, see cat. no. 53. This picture may be identified with 'a small picture of oil upon panel of North End, Hampstead', to which Linnell referred in his 'Journal' for 1831. It is not included in the list of works which Story appended to his *Life*.

Lent by the Museum of London

60 View on Hampstead Heath

Oil on board. 18.5 × 24.0 cm
COLLECTIONS: By descent from the artist to the present owner
EXHIBITION: London, Royal Academy, 1883, no. 20

See the entry for cat. no. 58. The small size of these two oils and the fairly free technique suggest that these may have been painted from nature, though Linnell's 'Journals' do not record this. The handling is similar to the oil painting *The Flight into Egypt* by Samuel Palmer at the Yale Center for British Art (no. 1764).

Lent anonymously

61 The Ferry, Itchen

Illustrated in colour
Oil on canvas. 34.5 × 95.0 cm
Signed and dated, below, 'J. Linnell fec. 1825.'
COLLECTIONS: Chambers Hall; the artist; with Messrs Frost & Reed 1920–5; Martyn Gregory
EXHIBITION: Edinburgh, Royal Scottish Academy, 1829, no. 168

It was because of the success of Linnell's picture *Southampton Water Seen from the River near Netley Abbey* (now in a private collection in England; repr. in *Zwei Jahrhunderte englische Malerei* (Munich, 1980), p. 449, no. 295) that its owner,

Chambers Hall, immediately commissioned a companion to it. Writing enthusiastically to Linnell about the earlier painting, Chambers Hall told him: 'You have indeed realised ideas which I had long cherished of a most magnificent effect of nature, the interest in which is heightened to me from the circumstance of locality ... My real ambition is now the Itchen Ferry (morning) as a companion to the sunset.'

Linnell had met this distinguished collector on his visit to Southampton in 1819. On that occasion Linnell had lodged with the artist D. C. Read, who knew Hall. (Read was also a friend of John Constable and was later the catalyst for the famous acrimonious exchanges between Linnell and Constable.)

In the Itchen Ferry painting Linnell abandoned the intense colouring of *Southampton Water* for a more prosaic, but nonetheless carefully observed, representation of morning. Evidently the clarity and precision of objects in daylight did not please the patron as much as the sunset romanticism of the *Southampton Water*, for in 1829 Linnell took back *The Ferry, Itchen* in exchange for *Evening, Storm Clearing Off.*

Lent by the Martyn Gregory Gallery, London

62 A Beech Tree

Pen and brown ink with watercolour and bodycolour over pencil, heightened with white chalk on grey paper. 551 × 451 mm
COLLECTIONS: By descent from the artist to the present owner
EXHIBITION: London, Colnaghi, 1973, no. 38
LITERATURE: Christiana Knowles, 'John Linnell: His Early Landscapes to 1830' (unpublished M.A. thesis, Courtauld Institute of Art, 1980), p. 48 and n.

A comparison of *A Beech Tree* with the Fitzwilliam drawing of a tree at Tythrop in 1817 (cat. no. 44) suggests that this drawing was done much later than the Tythrop studies. The use of bodycolour provides a more opaque effect and emphasises the volume of the tree in a way quite different from the more delicate drawings and watercolours of Linnell's sketching tours of 1813–18.

The *mise-en-page* with a low viewpoint and attention to detail invites comparison both with earlier studies of 1793 by Benjamin West of trees in Windsor Forest (Pierpont Morgan Library, New York, 970.11.1) and with drawings of oaks in Lullingstone Park which Palmer made in the late 1820s (see Grigson, *Samuel Palmer*, p. 169, pl. 25). Indeed, it is possible that the drawing was done in September 1828 when Linnell visited Palmer at Shoreham and sketched with him in Lullingstone Park.

Lent anonymously

63 The Weald of Kent

Pencil, pen and brown ink, brown wash. 275 × 381 mm irregular
Signed and dated, lower right, 'JL 1833'

COLLECTIONS: L. G. Duke (no. D.164); his sale, Sotheby's, 21 May 1970, lot 98, bought Thos Agnew & Sons; Theodore Besterman; his sale, Christie's, 17 Nov. 1981, lot 93, bought Thos Agnew & Sons on behalf of the Fitzwilliam Museum (Biffen Fund) (PD.27–1981)
EXHIBITIONS: London, Arts Council of Great Britain, *Samuel Palmer and his Circle*, 1957; Reigate, 1963, no. 37
LITERATURE: *Illustrated London News*, 23 Feb. 1957

The use of cursive pen and ink shows Palmer's influence on Linnell at this time.

Lent by the Fitzwilliam Museum, Cambridge

64 Underriver

Black chalk, pen and brown ink and brown wash on cream paper. 280 × 275 mm
Signed in ink, lower left, 'JL'
COLLECTIONS: L. G. Duke; Mrs W. W. Spooner; Sir John and Lady Witt (no. 1988)
EXHIBITION: London, Arts Council of Great Britain, *Samuel Palmer and his Circle*, 1957, no. 113

Although the paper is watermarked '1812', on stylistic grounds the drawing must date from *c.* 1833, the same time as *The Weald of Kent* (cat. no. 63). In a note on the mount, L. G. Duke states that David Gould 'tells me that this, like some of Palmer's drawings, is the view from *Poll Hill*, near Shoreham'. As Sir John Witt pointed out, the view is almost exactly that of Palmer's *The Golden Valley*, illustrated in L. Binyon, *The Followers of William Blake* (London, 1925), pl. 33.

Lent by Sir John and Lady Witt

65 Shoreham

Watercolour over pencil highlighted with white on brown paper.
279 × 441 mm
Signed and inscribed in brown ink, lower right, 'J Linnell', 'Kent'; inscribed in pencil, lower right, 'Shoreham' (twice)
COLLECTIONS: By descent from the artist to the present owner
EXHIBITIONS: London, Colnaghi, 1973, no. 66; Salisbury, Festival Exhibition, 1977, no. 6

Linnell's recorded visits to Shoreham are mainly in 1828, the year in which his journals record a complete physical – and perhaps mental – collapse. Shoreham, and the company of the Ancients, must have provided a welcome release from responsibilities. On 26 August 1828 Linnell wrote to Palmer: 'I have found so much benefit from my short visit to your valley, and the very agreeable way in which we spent the time, that [I] shall soon be under the necessity of seeing you again very soon at Shoreham ... I dream of being there every night almost and when I wake it is some time before I recollect that I am at Bayswater – for though I have been at many places on visits I never was anywhere so much at

liberty' (quoted in R. Lister (ed.), *The Letters of Samuel Palmer* (Oxford, 1974), I, p. 29).

Lent anonymously

66 Shepherd Boy Piping

Watercolour and bodycolour over pencil. 440 × 277 mm
Signed and inscribed in brown ink, lower right, 'J. Linnell Shoreham'; inscribed in pencil, right of centre, 'William L / n. 3[?]'
COLLECTIONS: By descent from the artist to the present owner
EXHIBITIONS: Reigate, 1963, no. 53; London, Colnaghi, 1973, no. 67

This study of a farmer's boy was made on Linnell's visit to Shoreham with George Richmond in 1829. Together with cat. no. 67, it provided a study for the oil painting *The Farmer's Boy,* of which no. 68 is probably a replica.

Lent from a Linnell private collection

67 Shepherd Boy Piping

Pencil and watercolour with touches of bodycolour. 264 × 216 mm
Signed and inscribed in ink, lower left, 'J. Linnell Shoreham'
COLLECTION: With Anthony Reed
EXHIBITIONS: London, Anthony Reed, and New York, David & Long Co., *English Sketches and Studios*, 1978 ?, no. 66, repr.

See the preceding entry.

Lent anonymously

68 Shepherd Boy Playing a Flute

Illustrated in colour
Oil on panel. 23.0 × 16.5 cm
Signed and dated, lower left, 'J Linnell ft 1831 [1837?]'
COLLECTIONS: Mrs Florence Donald; L. J. Drew, Esq.; Mr and Mrs Paul Mellon; Yale Center for British Art, Paul Mellon Collection (no. 323)
EXHIBITIONS: London, Tooth, 1882, no. 5?; Richmond, Va., Museum of Fine Arts, *Painting in England 1700–1850: The Collection of Mr and Mrs Paul Mellon*, 1963, no. 294
LITERATURE: Story, *Linnell*, II, p. 266

See the entry for cat. no. 66. This is probably a smaller replica of *The Farmer's Boy* (152.0 × 114.4 cm), which was exhibited at the Royal Academy in 1830, no. 251 (untraced). Linnell may perhaps have had in mind Blake's *Songs of Innocence* in painting this subject, as well as Palmer's work, though the boy and his dress are treated with due regard for their essential rural charm.

Lent by the Yale Center for British Art, Paul Mellon Collection

69 Mary Susanna Linnell

Pencil. 116 × 92 mm (irregularly trimmed)
Signed and dated in ink, lower left, 'J Linnell 1811'; inscribed in pencil, below, 'my mother'
COLLECTIONS: By descent to a granddaughter of the artist, Edith Bell, and from her to the present owner

A portrait done while Linnell was still living partly at 2 Streatham Street, Bloomsbury. There are several of these informal drawings of his mother, the informality of the pose often being reinforced by comments made by Linnell on the quality of the drawing. They show how Linnell had no natural ability to capture a likeness in his sitters – this despite his training at the Royal Academy. Portraiture was a skill he acquired out of necessity. He also believed that the fault of many landscape artists of his day derived from their inability to draw the human figure.

Lent anonymously

70 John Martin

Engraving. 427 × 335 mm
Signed in the plate 'PAINTED AND ENGRAVED BY I. LINNELL' and dated 'MAY 1813'
COLLECTIONS: By descent from the artist to the present owner

This is an engraving of Linnell's painting of John Martin, 125.0 × 97.5 cm, oil on canvas, 1812 (private collection). In his 'Autobiographical Notes' Linnell describes John Martin as 'a remarkable man – most upright in every sense of the word physically as well as morally'. Martin (1741–1820) was a Particular Baptist who caused a scandal in 1798 by announcing from the pulpit that were the French to land in England many dissenters would unite to encourage them. This opinion resulted in a large secession from his Chapel, but he continued to preach in central London, until 1814 at Grafton Street and later at Keppel Street, where Linnell met him. Martin's republican views, like those of his contemporary William Blake, clearly appealed to Linnell.

Lent anonymously

71 Self-Portrait

Pencil heightened with white chalk. 140 × 100 mm
Inscribed, signed and dated in pencil, below, 'myself J. Linnell 1815'
COLLECTIONS: By descent from the artist to the present owner

This, the earliest known self-portrait by Linnell, shows him at the age of twenty-three.

Lent from a Linnell private collection

72 Self-Portrait

Pencil. 185 × 133 mm
Inscribed and signed in pencil, lower right, 'self / J.L.'
COLLECTIONS: Bought Thos Agnew & Sons, Jan. 1968 (no. 87) by the present owner

As in the other self-portrait exhibited (no. 71), Linnell's intensity of concentration is particularly marked around the eyes.

Lent anonymously

73 Portrait of Philip Thomas Wykeham and Hester Louisa, his wife, with their sons Philip and Aubrey and Mrs Trotman, mother of Mrs Wykeham

Oil on panel. 54.5 × 70 cm
Signed and dated, below, 'I. LINNELL Fec. / 1817'
COLLECTIONS: By descent to the present owner
LITERATURE: British Museum, Linnell's 'Portrait Sketchbook'; Story, *Linnell*, vol. II

Between 1817 and 1819 Linnell maintained a close connection with the Wykeham family of Tythrop House, near Thame in Oxfordshire. He painted this group portrait on his first visit there in 1817, and stayed to paint a double portrait of Mr and Mrs Fiennes Trotman (the father and mother of Mrs Wykeham) in the same month. The family portrait was not a complete success on its reception in December 1817; by then Philip Wykeham had changed his mind about the pose of his wife. Linnell painted her originally turned to face her husband, but was required by Wykeham to paint her as she now appears, in profile. On succeeding visits to Tythrop in 1818 and 1819 the painting was altered to suit the family's requirements, though this created some awkwardness in the scale of the figures. The painting cost seventy-five guineas.

The Tythrop connection was an important one for Linnell, as it provided him with the opportunity to study landscape (see cat. no. 44) while earning an income from portraits. Linnell also cleaned or repaired the Wykeham collection of some thirty minor seventeenth-century paintings.

Lent anonymously

74 HRH The Princess Sophia Matilda

Watercolour miniature on ivory. 124 × 105 mm
Signed and dated 'J. Linnell 1821'
COLLECTIONS: The Royal Collection
EXHIBITIONS: London, Royal Academy, *Winter Exhibition*, 1951, no. 640; Royal Academy, *Bicentenary Exhibition*, 1968–9, no. 757
LITERATURE: Story, *Linnell*, I, p. 124; B. S. Long, *British Miniature Artists* (London, 1929), p. 274

James Holmes, who was Linnell's neighbour in Cirencester Place, suggested that

Linnell should try his hand at miniature painting. In his 'Portrait Sketchbook', two references are made in 1816 to miniatures on ivory of Mrs Anderson's and Mr Joseph Guilt's daughters, although in his 'Autobiographical Notes' Linnell stresses that the portrait miniature of his wife, Mary Ann Linnell, begun in 1818 (private collection, England), was his first attempt.

In his 'Autobiographical Notes' Linnell wrote: 'Miniature portraits at that time had in general nothing in them beyond the locket and brooch style – jewellers work, with no pretention to fine art. It never seemed to have occurred to any painter of such things that all which Reynolds had done on a large scale in oil could be done on a small one in any material. When I tried upon ivory to paint a small head of my wife in 1819, I found without knowing how different it was from miniature painting in general that it surprised many . . .'

John Varley took this miniature of Mrs Linnell to the Marchioness of Stafford, which led to a number of commissions to paint members of her family and acquaintance, and finally to a commission from the Royal Family. '. . . at last [in] 1821 I had to paint a miniature of the Princess Sophia . . . it was for the Duke of York I believe. I ventured to make my picture really like though as favourable as truth would admit of, and I conclude it was on that account I did no more in that connection.' Perhaps the attitude to his sitter implicit in this comment communicated itself to his royal patron. Another miniature on ivory of Princess Sophia is in a private collection. Both are included in the 'Portrait Sketchbook'.

Lent by Her Majesty The Queen

75 Lady Torrens and her Family

Illustrated in colour
Oil on canvas. 109.8 × 139.8 cm
Signed and dated, left of centre, 'Jⁿᵒ. LINNELL: F: 1820.'
COLLECTIONS: Sir Henry Torrens; Christie's sale, 23 Nov. 1979, lot 144; with Thos Agnew & Sons, 1980, from whom acquired by Mrs Richard Selle, New York
EXHIBITIONS: London, Royal Academy, 1821, no. 375; Thos Agnew & Sons, *The Portrait Surveyed: British Portraiture 1670–1870*, 1980, no. 44
LITERATURE: British Museum, Linnell's 'Portrait Sketchbook'; Linnell MSS., 'Journal' and 'Autobiographical Notes'; Story, *Linnell*, I, pp. 115ff; II, p. 247

The picture was begun in April 1819 and completed in April 1821. It was exhibited in the Royal Academy of the same year, and contains the portraits of Lady Torrens and her six children.

Linnell in his 'Autobiographical Notes' credits John Varley with providing him with introductions to portrait sitters; many wealthy amateurs of art who were taught watercolour painting by Varley had their portraits painted by Linnell. Linnell met Colonel Dumaresque in this way, and he, pleased with his portrait, immediately recommended the artist to Sir Henry and Lady Torrens. Lady Torrens, née Patton, was the daughter of the governor of St Helena. She met and fell in love with Henry Torrens (1779–1828) when he put in there in 1802 to recuperate from sunstroke on his way home to England from Bombay.

Torrens had a distinguished military career; he was military secretary to Sir Arthur Wellesley (later 1st Duke of Wellington) in 1808 and was made Knight Commander of the Order of the Bath in 1814. At the time of the portrait, Torrens was Adjutant-General of the Forces. The Torrens portrait was remarkable if for no other reason than that it marked the beginning of a great friendship between Linnell and Lady Torrens, perhaps the only one Linnell made with one of his titled clients. There are several references in the 'Autobiographical Notes' to 'the great kindness of one scotchwoman, who was the greatest friend I ever had, the dear kind and accomplished Lady Torrens'. Linnell clearly regarded her as the perfect wife and mother, who educated her six children in 'harmony and happiness'. The Torrens portrait also provided the opportunity to work on what was for Linnell a large-scale portrait, the composition of which owes much to Lawrence, who had painted Sir Henry Torrens in 1816 (Corporation of Londonderry).

Lent by Mrs Richard Selle, New York

76 Edward Denny

Oil on board. 47 × 37 cm
Signed and dated, top right, 'I. Linnell F. 1821'
COLLECTIONS: By descent to the present owner
EXHIBITION: London, Royal Academy, 1822, no. 34
LITERATURE: British Museum, Linnell's 'Portrait Sketchbook'

Edward Denny (b. 1796) succeeded to his father's baronetcy in 1831. When Linnell painted him ten years earlier, at the age of twenty-five, he was a friend and admirer of William Blake, who later bought off Linnell a copy of Blair's *Grave* and the *Job* engravings. Linnell's method of obtaining the commission was characteristic: he produced the portrait 'on spec' and showed it to both Edward and his parents. This resulted in Denny's own purchase of his portrait and a commission for five more: of Edward Denny's parents, Sir Edward and Lady Denny, and their children Elizabeth, William and Diana.

Lent from a private collection

77 William Blake in Conversation with John Varley

Pencil on Whatman paper (watermarked). 113 × 176 mm
Signed and dated in pencil, lower right, 'J.L. Sept. 1821'. Inscribed in pencil, lower left, 'Cirencester place' and, beneath the figures in identification, 'Mr Blake / Mr Varley'
Verso: slight pencil sketch of the same composition
COLLECTIONS: The artist; the Linnell Trustees; Linnell sale, Christie's, 15 March 1918, lot 169, bought Carfax for T. H. Riches, by whom bequeathed to the Fitzwilliam Museum, 1935; received on the death of his widow, 1950 (PD.59–1950)
EXHIBITIONS: London, Tate Gallery, Manchester, Whitworth Institute, and Nottingham, Castle Museum, *Works by William Blake*, 1913–14, nos. 109, 172, 132; Edinburgh, National Gallery of Scotland, *Works by William Blake and David Scott*, 1914, no. 119;

Cambridge, Fitzwilliam Museum, *William Blake*, 1970, no. 50; London, Colnaghi, 1973, no. 1066; Tate Gallery, *William Blake*, 1978, no. 280

LITERATURE: Sir Geoffrey Keynes, *A Bibliography of William Blake* (New York, 1921), pp. 482–3, no. 17, repr. pl. 37; L. Binyon, *The Followers of William Blake* (London, 1925), repr. pl. 1; M. Wilson, *The Life of William Blake* (London, 1927), repr. pl. xix; Martin Butlin, *The Blake–Varley Sketchbook of 1819* (London, 1969), p. 8, repr. facing p. 10; G. E. Bentley, Jr., *Blake Records* (Oxford, 1969), p. 274; *William Blake: Catalogue of the Collection in the Fitzwilliam Museum, Cambridge*, ed. David Bindman (Cambridge, 1970), no. 50; Sir Geoffrey Keynes, *The Complete Portraiture of William and Catherine Blake* (London, 1977), pl. 30, pp. 137/8

Martin Butlin (p. 8) draws attention to Linnell's reference to this drawing in his 'Autobiographical Notes' of 1864: 'Varley believed in the reality of Blake's visions more than even Blake himself – that is in a more literal and positive sense that did not admit of the explanations by which Blake reconciled his assertions with known truth. I have a sketch of the two men as they were seen one night in my parlour near midnight, Blake sitting in the most attentive attitude listening to Varley who is holding forth vehemently with his hand raised – the two attitudes are highly characteristic of the men for Blake by the side of Varley appeared decidedly the most sane of the two.'

Lent by the Fitzwilliam Museum, Cambridge

78 William Blake

Watercolour miniature on ivory. 133 × 111 mm

COLLECTIONS: The artist; the Linnell Trustees; Linnell sale, Christie's, 15 March 1918, lot 179, bought Carfax for T. H. Riches, by whom bequeathed to the Fitzwilliam Museum, 1935; received on the death of his widow, 1950 (PD.61–1950)

EXHIBITIONS: London, Royal Academy, 1883, no. 102–7?; London, Tate Gallery, Manchester, Whitworth Institute, and Nottingham, Castle Museum, *Works by William Blake*, 1913–14, nos. 111, 140, 126; Edinburgh, National Gallery of Scotland, *Works by William Blake and David Scott*, 1914, no. 124; Cambridge, Fitzwilliam Museum, *William Blake*, 1970. no. 49; London, Colnaghi, 1973, no. 107

LITERATURE: A. T. Story, *William Blake: His Life, Character and Genius* (London, 1893), repr. as frontispiece; Sir Geoffrey Keynes, *A Bibliography of William Blake* (New York, 1921), p. 480, no. 4; *William Blake: Catalogue of the Collection in the Fitzwilliam Museum, Cambridge*, ed. David Bindman (Cambridge, 1970), p. 56, no. 49, repr. pl. 66; Sir Geoffrey Keynes, *The Complete Portraiture of William and Catherine Blake* (London, 1977), pl. 26, pp. 135/6

This portrait of Blake is dated 1821 by the inscription which appears on a watercolour copy of it by the artist in the National Portrait Gallery, London (no. 2146). That is signed and dated 1861, but claims to be a 'Fac Simile of a Portrait on Ivory painted from life by John Linnell 1821'. The engraving by Jeens which was used as a frontispiece to Gilchrist's *Life of Blake* (London, 1863 and subsequent editions) misquotes the date of the ivory as 1827.

Lent by the Fitzwilliam Museum, Cambridge

79 The Cowper Madonna

Watercolour miniature on ivory. 176 × 136 mm
Signed and dated, lower left, 'J.L. 1822'
COLLECTIONS: By descent to a great-great-granddaughter of the artist, from whom acquired by the present owner
EXHIBITION: London, Colnaghi, 1973, no. 73

This copy by Linnell of the larger Raphael Madonna owned by Lord Cowper was begun by Linnell on 22 April 1822 and finished on 3 May. Linnell's journal does not give details of his travelling to Lord Cowper's seat at Panshanger Hall, near Hertford, and it is possible that Linnell may have seen the painting exhibited elsewhere. Lord Cowper's painting was well known and highly esteemed in the early part of the nineteenth century. J. D. Passavant in his *Tour of a German Artist in England* ... (2 vols., London, 1836) describes the painting as 'exquisitely beautiful ... although rather slight in execution' (1, p. 221). The larger Cowper Madonna is now in the National Gallery of Art, Washington, D.C., U.S.A. (no. 25). Linnell's copy was not produced for engraving; the artist seems to have painted it for himself, as the miniature remained in the Linnell family until recently.

Lent anonymously

80 George Rennie

Watercolour miniature on ivory. 121 × 89 mm
Signed and dated, left of centre, 'I.L.F. / 1824'. Inscribed by Linnell on the back of the card on which the miniature is mounted 'Portrait of / George Rennie Esqr / Painted from life by / John Linnell / Sept 1824– / London / no 6 Cirencester Place / Fitzroy Sqr.'
COLLECTIONS: The Misses A. and E. Rennie, 1892; Euart Wheeler, 1949, from whom purchased by the National Portrait Gallery (no. 3685)
EXHIBITION: London, Colnaghi, 1973, no. 100
LITERATURE: Story, *Linnell*, II, p. 255; D. Foskett, *British Portrait Miniatures* (London, 1963), p. 176; R. Ormond, *Catalogue of Early Victorian Portraits in the National Portrait Gallery* (London (H.M.S.O.), 1973), p. 392

George Rennie (1791–1866) was a civil engineer, the eldest son of the engineer John Rennie (1761–1821). He entered into partnership with his brother, Sir John Rennie (1794–1874), and had a considerable business as a railway engineer. The town in the background has not been identified, and the bridge is none of those with the building of which we know (from the *Dictionary of National Biography*) that Rennie was involved.

Lent by the Trustees of the National Portrait Gallery

81 Mrs William Wilberforce and Child

Illustrated in colour
Watercolour and bodycolour over pencil, with some scraping out, on a scored gesso ground on panel. 362 × 267 mm

Signed and dated in brown ink, lower right, 'by John Linnell 1824'; inscribed in brown ink, lower left, 'Water Colors / Mᵣˢ William Wilberforce'
COLLECTIONS: R. E. Abbott; his sale, Christie's, 4 Nov. 1955, unspecified lot; Leonard G. Duke (no. 8125); Mr and Mrs Paul Mellon; Yale Center for British Art, Paul Mellon Collection (B 1977.14.5308)
EXHIBITIONS: London, Arts Council of Great Britain, *Samuel Palmer and his Circle*, 1957, no. 110; New Haven, Conn., Yale Center for British Art, *English Landscape 1630–1850: Drawings, Prints and Books from the Paul Mellon Collection*, 1977, and *English Portrait Drawings and Miniatures*, 1979–80, no. 107, repr.

Mrs William Wilberforce was the daughter of John Owen, Secretary of the Bible Society at Harrow. In 1820 she married William Wilberforce (1798–1897), the eldest son of the philanthropist and abolitionist of slavery, William Wilberforce (1759–1833).

Linnell exhibited an untraced oil portrait of Mrs Wilberforce and child at the Royal Academy in 1824 (no. 50). The sketch of the painting which survives in Linnell's 'Portrait Sketchbook' establishes the closeness of the composition to this watercolour, which corresponds also in size. The technique he used casts an interesting light upon Linnell's relationship to Blake. As Patrick Noon has pointed out (*English Portrait Drawings and Miniatures*, Yale Center for British Art (New Haven, 1979), p. 101), his use of a gessoed ground was inspired by Blake's 'Fresco' paintings, and in his *Descriptive Catalogue* (London, 1809, p. 3) Blake commented: 'Let / it be observed, that before Van dykes time, and in his time all the genuine Pictures are on Plaster or Whiting grounds, and none since.' Linnell certainly knew Blake's attempts in the medium, in particular the Arlington Court picture of 1822 (National Trust, Arlington Court, Devonshire), which his father framed. Blake believed that his method was faithful to Renaissance practices, although by 1824 Linnell was probably better informed as a result of his reading of Cennino Cennini's *Il Libro Dell' Arte*.

Along with Blake, Flaxman (1755–1826), Fuseli (1741–1825) and Stothard (1755–1834), Linnell spent a considerable amount of time, *c.* 1824, in the house of the German banker Charles Aders and his wife, the daughter of John 'Warwick' Smith. Aders had a notable collection of Flemish art by Memling, Petrus Christus and the van Eycks, and in 1824 he commissioned Linnell to paint a copy of a copy he owned of Jan van Eyck's *Adoration of the Lamb* Ghent altarpiece (untraced). Linnell's portrait of Mrs Wilberforce is a curious reconstruction of fifteenth-century painting technique, in watercolour and bodycolour, to represent the sitter's unmistakably nineteenth-century features.

Lent by the Yale Center for British Art, Paul Mellon Collection

82 Mrs Thompson

Oil on panel. 35.5 × 25.5 cm
Signed and dated, lower left, 'J Linnell / 1830'
COLLECTIONS: Sold Christie's, 30 March 1972, lot 174, bought by the present owner

Mrs Thompson was the mother-in-law of Peter Walker, who did all the

carpentering and joinery on the house which Linnell designed and had built at No. 38 Porchester Terrace, Bayswater. The portrait was part of Linnell's payment to Walker. This barter arrangement was used by Linnell for all the tradespeople engaged on the house. A memorandum in Linnell's journal for 1830 explains the arrangement: 'Mr Walker came and agreed to do all the remaining carpenter's work ... and to take 40% in pictures.' Linnell saw himself as another kind of tradesman, with an identifiable and quantifiable price for his goods.

Lent anonymously

83 The Reverend Thomas Robert Malthus

Oil on panel. 37.2 × 31.1 cm
Signed and dated, below, right of centre, 'I. LINNELL F. / 1833'
COLLECTIONS: By descent to a great-great-nephew of the Rev. T. R. Malthus, Mr R. Malthus, who presented the portrait together with that of Mrs Malthus to the present owners
EXHIBITIONS: London, Royal Academy, 1833, no. 215; Royal Academy, 1883
LITERATURE: British Museum, Linnell's 'Portrait Sketchbook'; Story, *Linnell*, II, p 249; *The Haileyburian*, Feb. 1972, pp. 158–9

The Reverend Thomas Malthus (1766–1834) was entered a pensioner of Jesus College, Cambridge in 1784; he became a fellow and was in holy orders in 1793. His famous theory of population was expounded in the *Essay on Population* which he published anonymously in 1798. A summary of his social and political views appeared in *Political Economy* (1820). Meanwhile, in 1805 Malthus became Professor of Political Economy at the newly founded East India College at Haileybury in Hertfordshire. He lived there quietly for the rest of his life. In 1819 he was elected F.R.S. and in 1821 became a member of the Political Economy Club, founded in that year by Thomas Tooke. He was one of the ten associates of the Royal Society of Literature elected in 1824 and ten years later was one of the first fellows of the Statistical Society. Linnell painted portraits of Malthus and his wife at Haileybury in 1833.

Lent anonymously

84 William Mulready

Oil on panel. 311 × 254 mm
Signed and dated, left of centre, 'J. Linnell. fect / 1833'; inscribed, top left, 'WmMULREADY Esqr R.A'
COLLECTIONS: Sold to John Gibbons, 1846; by descent to John Gibbons and purchased for the National Portrait Gallery at his sale, Christie's, 29 Nov. 1912, lot 108 (no. 1690)
EXHIBITIONS: London, Royal Academy, 1833, no. 162; South Kensington Museum, *Third Exhibition of National Portraits*, 1868, no. 551: New Gallery, *Victorian Exhibition*, 1891–2, no. 174; Colnaghi, 1973, no. 103

LITERATURE: British Museum, John Linnell's 'Portrait Sketchbook'; Story, *Linnell*, II, p. 249 (erroneously said to have been done in 1831); R. Ormond, *Catalogue of Early Victorian Portraits in the National Portrait Gallery* (London (H.M.S.O.), 1973), I, p. 327

The portrait was engraved by I. Thomson. Another version of the painting, unfinished and without the palette, is in the National Gallery of Ireland (30 × 25 cm).

Linnell had first met the artist William Mulready (1786–1863) at the home of John Varley, whose sister Mulready had married in 1803. In the first decade of the nineteenth century Linnell's admiration for Mulready was boundless, and he readily acknowledged Mulready's influence and tuition. Between 1808 and 1812 the two artists were inseparable, and their friendship may have been a contributory factor in the breakdown of Mulready's marriage in 1809. After 1812 there are few mentions of Mulready in the Linnell manuscripts; whether they became alienated from one another because of Linnell's religious beliefs, or because of Mulready's early success in domestic genre painting or his easy election to the Royal Academy (A.R.A. 1815; R.A. 1816) is not known. It is surprising that there are no portrait drawings or paintings by Linnell of Mulready dating from the period of their close association, although he is known to have sat for the painting *The Cottage Door* (1809). This portrait is a formal one.

Lent by the Trustees of the National Portrait Gallery

85 Portrait of Samuel Palmer

Pen and brown ink. 323 × 189 mm (irregularly trimmed)
Signed in brown ink, lower right, 'J. Linnell'; inscribed in pencil (in another hand), below, 'Portrait of Sam' Palmer'
COLLECTIONS: By descent from the artist to the present owner
EXHIBITION: Colnaghi, 1973, no. 88
LITERATURE: Ormond, *Early Victorian Portraits*, I, p. 357

The cursive pen and ink technique of the portrait suggests a date towards the end of Palmer's Shoreham period, probably in the early 1830s. The features and hairstyle are similar to the study of Palmer which was used for Linnell's *Road to Emmaus* of 1834–8, now in a private collection.

Lent anonymously

86 Mary Linnell

Oil on panel with additions to panel made by the artist. 25.0 × 16.5 cm
Signed, lower right, 'J. Linnell f'; inscribed, *verso*, 'Portrait of the Artist's daughter, Mary'
COLLECTIONS: With Martyn Gregory, from whom acquired by the present owner
EXHIBITION: London, Gregory & Kruml, *December Exhibition*, 1974, no. 32

Mary Ann Linnell (29 June 1828–7 April 1883) was the third daughter and sixth child of John Linnell. She went to live with her brother William when his wife

died in 1869 to look after his three small children, and died unmarried in 1883. Like most of the Linnell children, she was taught by her father to draw and paint, and specialised in wild-flower painting, many examples of which remain in the family. As she appears here to be about ten, the picture must have been painted *c.* 1838.

Lent anonymously

87 John Claudius Loudon, F.L.S., H.S., F.S., G.S.

Oil on canvas. Restored in 1978 by Mrs Philippa Jefferies of Cheltenham through the generosity of Joan Linnell Ivimy, great-granddaughter of the artist. 75 × 60 cm
Signed and dated, left of centre, 'J Linnell / 1840–1'
COLLECTIONS: Bought from the artist's studio by subscription in 1878 as a gift to the Linnean Society in memory of John Loudon
EXHIBITION: London, Royal Academy, 1883, no. 25
LITERATURE: Story, *Linnell*, II, p. 251; J. Gloag, *Victorian Taste* (London, 1962), pl. 4

Linnell was not commissioned by the sitter, John Claudius Loudon (1783–1843), the architect, landscape gardener, writer on horticulture and encyclopaedist, who was his neighbour in Porchester Terrace from 1838. In that year Loudon and Linnell both completed the design and building of their respective houses there, nos. 3 and 38. The portrait came into being as a result of Linnell's great admiration for Loudon's work in gardening and horticulture. Linnell practised both avidly, to provide a self-sufficient household in what was still a rural area. The painting is a good example of Linnell's mature style of portraiture, in which the modelling of the features is soft. Loudon is posed appropriately in front of a landscaped garden background.

Lent by permission of the Council of the Linnean Society of London

88 Lady Perry

Pencil, watercolour and some white on buff paper. 342 × 365 mm
COLLECTIONS: T. H. Riches, by whom bequeathed to the Fitzwilliam Museum, Cambridge, 1935; received on the death of his widow, 1950 (PD.63–1950)

Louisa M'Elkiney, a niece of Mme Jérome Bonaparte, married Thomas Erskine Perry in 1834. In 1840 he was made Judge of the Supreme Court of Bombay and was knighted on 11 February 1841. He was sworn into his judicial office at Bombay on 10 April of that year, and Lady Perry died at Byculla on 12 October. In Linnell's 'Portrait Sketchbook' there is a record of this portrait under the year 1841 inscribed 'Lady Perry', so this must have been drawn shortly after 11 February and before the Perrys left for India. Several watercolours are recorded in the 'Portrait Sketchbook'; clearly Linnell considered them finished works.

Lent by the Fitzwilliam Museum, Cambridge

89 The Morning Walk

Oil on canvas. 75 × 62 cm
Signed, lower left, 'J Linnell'
COLLECTIONS: John Gibbons; by descent to the present owner
EXHIBITION: London, Royal Academy, 1847, no. 265, with a quotation from Thomson:
'When happy muse and every blooming pleasure wait without to bless the wildly-devious
morning walk'
LITERATURE: Linnell MSS., 'Journal' for 1847; Story, *Linnell*, ii, p. 252

The portrait is of Elizabeth Gibbons, née Steen (*c.* 1806–89), the wife of John
Gibbons, the Midlands ironmaster who was one of Linnell's major patrons in the
late 1840s and early 1850s. By this period in his career, the emergence of patrons
and dealers provided Linnell with sufficient demand for his landscapes so that he
had no need of the income from portraits. It was perhaps as a favour to one of his
best customers that Linnell painted this portrait of Mrs Gibbons, giving it a title
which comes from the quotation from Thomson attached to it at its first
exhibition, and which may also allude to Gainsborough's portrait of Mr and Mrs
Hallett. This three-quarter portrait, together with one of the Gibbonses' doctor,
Dr Meryon, and one of their solicitor, *Mr Carter*, were the last he painted on
commission. Studies for the portrait were made at John Gibbons's town house in
Regent's Park.

Lent anonymously

90 Landscape

Oil over pencil on prepared paper on board. 7.8 × 48.2 cm
Inscribed, *verso*, in ink, in different hands: 'Van Strag asserts that / copal was constantly /
used by Cuyp his / pictures are remarkably hard – G.C.' (George Cumberland); 'This is G⁵ᵒ
Cumberland of / Bristol, who introduced Linnell to Wᴹ Blake'; 'By Linnell'; 'Painted by J.
Linnell / as a painting lesson – for Geo Cumberland – / about 1840. =´; 'Given to me by Miss
Cumberland / sister of Geo Cumberland for whom John / Linnell paint it at a sitting to show
her / brother how he commenced his pictures / H [?] B [in monogram] Mar 1887'; 'Geo
Cumberland / of Bristol, 11 am / enlightened Patron of Art / (Garnett), who introduced /
Linnell to Blake.'
COLLECTIONS: George Cumberland, jun.; Miss Cumberland; H ? B; Miss E. Grimes; sold
Christie's, 11 May 1921; Moore; with Jack Baer, from whom bought by the present owner
EXHIBITION: London, Hazlitt, *The Tillotson Collection*, 1965, no. 49, repr. pl. 20

John Linnell was introduced to William Blake by George Cumberland junior in
1818. He was an amateur artist whom Linnell taught intermittently during the
1820s. The evidence of the inscriptions on the *verso* implies that this was done
rather later, *c.* 1840, 'at a sitting to show . . . how he commenced his pictures' and
that Linnell did not consider this to be a finished painting. The paint is clearly
applied very fast with highlights put on in solid dabs; the overall effect is loose
and brilliant. In the 1830s, when Linnell was living in Bayswater, he and
Mulready experimented at some length with home-made grounds and varnishes.
On the advice of John Glover, Linnell experimented with the use of oil copal

varnish as a vehicle for oil pigment. He and Mulready believed it would be useful for its hard surface, its quick-drying property and the viscous quality of the oil which allowed a technique (evident here) of applying thin transparent washes of oil, building up layer upon layer. A disadvantage of oil copal is that it can turn colours yellow, even brown, so towards the end of the Bayswater period Linnell abandoned it in favour of linseed oil, which does not have such a discolouring effect. This may explain the usually excellent condition of the post-1857 landscapes.

Lent anonymously

91 Summer Evening, Boys Bathing, Harrow in the Distance

Oil on canvas, 36.25 × 57.5 cm
Signed and dated, below, 'J. Linnell / 1848'
COLLECTIONS: William Wethered; Richard Newsham, who bequeathed it to the Harris Museum and Art Gallery, Preston, 1883 (no. 382)
EXHIBITIONS: London, British Institution, 1849, no. 313; Royal Academy, 1883, no. 31
LITERATURE: British Museum, Linnell's 'Landscape Sketchbook'; Story, *Linnell*, II, p. 269; *Newsham Bequest Catalogue* (Preston, 1883); S. H. Paviere, *The Principal Pictures in the Harris Museum and Art Gallery, Preston* (1949), repr. p. 60

In his 'Landscape Sketchbook' Linnell describes the picture as being '@. 24.28.' (inches) and in the British Institution catalogue as 2.4 × 3.0 (feet and inches). It would appear, therefore, that the canvas is now about half its original height and has lost several inches in width. The picture was at its present size in 1883.

The subject was tackled earlier by Linnell; it is worth comparing this painting with *Evening, Bayswater* of 1818 in the Paul Mellon Collection (no. 122), for although the composition is reversed, the pictures share the same features of a lake to one side of the picture, cut off by the picture frame, and low-lying landscape stretching into the distance. Linnell seems to have used his Hampstead and Harrow watercolours of the 1820s (see cat. no. 52) for this 1848 painting.

Lent by the Harris Museum & Art Gallery, Preston

92 The Halt by the Jordan (St Philip Baptising the Ethiopian)

Oil on canvas. 96.25 × 133.75 cm
Signed 'J. Linnell'
COLLECTIONS: Sir Thomas Baring (150 guineas); sold at the Baring sale to the dealer Rought (112 guineas), who sold to Mr Holmes; Mr Rutherford (£500); Mr Ruffard, from whom bought, 1864, by Thos Agnew & Sons; sold by them to William Graham; Mr Fowler, from whom bought, 1868, by Thos Agnew & Sons and sold to N. J. Holdsworth; part of the Ashbee Bequest to the Victoria & Albert Museum, 1900 (no. 1845–1900)
EXHIBITION: London, Royal Academy, 1840, no. 403, with these lines: 'And he commanded the chariot to stand still; and they went down both into the water, both Philip and the eunuch, and he baptised him. Acts viii, 27 and 28'

LITERATURE: British Museum, Linnell's 'Landscape Sketchbook'; Story, *Linnell*, II, pp. 194–5, 267; *Art Journal*, 1859, p. 248

Linnell contemplated the subject first in 1819, the year after he began work on the companion piece, *St John Preaching in the Wilderness*. A sketchbook in the British Museum (1967–12–9–1) shows some early drawings for the baptism in the water, with Linnell testing out several poses (pp. 38, 40, 42, 48, 50). The composition recalls Jan Both's treatment of the subject, of which there were in 1839 two versions in the country. One was in the Royal Collection, which Linnell may have seen at the time of painting the miniature portrait of Princess Sophia (cat. no. 74) in 1821. The other belonged to Lord Methuen, whose portrait Linnell did not paint until 1844, but whose collection he had already studied. Both and Linnell used the similar device of the large saucer-shaped pool with foliage built up on the left-hand side of the picture, and a pathway around the pool on which the caravan of travellers passes. Although Linnell's early studies of mountainous countryside in Wales and Dovedale are scarcely recognisable by 1839–40, they continue to provide the rich landscape setting for the subject. For both Linnell and the patron who commissioned the work (the banker Sir Thomas Baring), the iconography of the painting was important. Thus St Philip and the Ethiopian, who stand beside the pool in the Both painting, are plunged into the water in Linnell's composition, to demonstrate total immersion, the form of baptism advocated by dissenting groups such as the Baptists Linnell had recently left and the Plymouth Brethren he had recently joined. The figures were later painted out by another hand (see introduction, p. xvi).

Lent by the Victoria & Albert Museum, London

93 Noah: The Eve of the Deluge

Illustrated in colour

Oil on canvas, relined. 144.7 × 223.5 cm

Signed and dated, lower right, 'J. LINNELL / 1848'

COLLECTIONS: Joseph Gillott, Birmingham; his sale, Christie's, 19 and 26 April and 3 May 1872, lot 137, bought J. Rhodes for Angus Holden (£1,092); Angus, 1st Lord Holden, Bradford; his sale, Christie's, 18 July 1913, lot 64, bought Ball (£180); Mrs C. Hunter; her sale, Sotheby's, Belgravia, 22 Feb, 1972, lot 98, bought J. Mass; with Herner Wengraf Ltd, London, from whom acquired by the Cleveland (Ohio) Museum of Art (Mr and Mrs William H. Marlatt Fund), 1975 (72.119)

EXHIBITION: London, Royal Academy, 1848, no. 620, with the first words of the following quotation from Milton:

> When lo! a wonder strange!
> Of every beast and bird and insect small
> Came sevens and pairs and entered in, as taught
> Their order: last the sire and his three sons
> With their four wives, and God made fast the door.
> Meanwhile the south wind rose, and with black wings
> Wide hovering, all the clouds together drove
> From under Heaven

LITERATURE: British Museum, Linnell's 'Landscape Sketchbook'; *Art Journal*, 1850, p. 230; 'John Linnell', *Art Journal*, 1859, pp. 106ff; *Dublin University Magazine*, Nov. 1877; *London Society*, no. 43 (1883), p. 217; F. G. Stephens, 'The Aims, Studies and Progress of

John Linnell, Painter and Engraver', *Art Journal*, 45 (Jan. 1883), 38, 39; *The Works of John Ruskin*, ed. E. T. Cook and A. Wedderburn, 39 vols. (London 1903–12), II, p. 334; Story, *Linnell*, II, pp. 18ff, 268–9; B. Denvir, 'Pens and Patronage', *Connoisseur Year Book*, 1958, pp. 72ff; E. R. Firestone, 'John Linnell and the Picture Merchants', *Connoisseur*, 182 (Feb. 1973), 125; *idem*, 'John Linnell: The Eve of the Deluge', *Bulletin of the Cleveland Museum of Art*, 62, pt 4 (April 1975), 131–9

When in 1847 the painting was sufficiently advanced Linnell sought the right buyer for this important work. He invited John Gibbons and Joseph Gillott to see it, Gibbons offering for the picture first. According to his 'Journal' and 'Landscape Sketchbook', Linnell then asked each man to write down secretly a price for the picture; the bidder who offered nearest to Linnell's own estimate would be the owner. Joseph Gillott offered and paid £1,000 for the picture. He also bought from Linnell in 1850 a smaller oil sketch of the subject, which was retouched in 1858. This is now in a private collection. In Linnell's estimation this was clearly one of his most important works. Although his great successes with dealers, patrons and the market date from this painting, works of this type were not hereafter amongst his most successful. *Noah* was the only painting by Linnell to attract the public attention of John Ruskin, who noted the artist's 'observance of nature scrupulously and minutely patient, directed by the deepest sensibility and aided by a power of drawing almost too refined for landscape studies and only to be understood by reference to his engravings after Michelangelo.' Ruskin's conclusion was that Linnell's effort was misguided: 'for though possessing many merits, it had no claim whatever to be ranked among productions of creative art' (*Modern Painters*, II, p. 241).

Linnell cannot have been unaware of John Martin's *Eve of the Deluge* of 1840 (Royal Collection), and he went out of his way to visit Francis Danby's version of the subject when it was exhibited in 1840. The figures in Linnell's painting are reminiscent of the bearded ancients in Martin and Westall's Bible of 1815, for which Linnell had designed a clasp.

Lent by the Cleveland Museum of Art (Ohio)

94 The Return of Ulysses

Oil on canvas. 122.5 × 108.2 cm

Signed and dated, lower right. between lines 2 and 3 of the inscription, 'J. Linnell. 1848.'; inscribed in various positions, lower right,

ΔΗ ΤΟΤΕ Γ ΑΤΡΕΜΑΣ ΕΥΔΕ
ΛΕΛΑΣΜΕΝΟΣ ΟΣΣ ΕΠΕΠΟΝΘΕΙ

[ΠΡΩΤΟΝ] ΟΔΥΣΣΗΑ ΓΛΑΦΥΡΗΣ
ΕΚ ΝΗΟΣ ΑΕΙΡΑΝ

[ΑΥΤΩ] ΣΥΝ ΤΕ ΛΙΝΩ ΚΑΙ ΡΗΓΕΙ
ΣΙΓΑΛΟΕΝΤΙ

[ΚΑΔ Δ ΑΡ ΕΠΙ] ΨΑΜΑΘΩ ΕΘΕΣΑΝ
ΔΕΔΜΗΜΕΝΟΝ ΥΠΝΩ

ΩΜΗΡΟU
ΟΔΥΣΣΕΙΑΣ

COLLECTIONS: Joseph Gillott, 1848; Joseph Pennell; William Wilson, Esq., Manchester, 1857; John Graham, Skelmorlie Castle, Scotland; his sale, Christie's, 30 April 1887, lot 76 (1,400 guineas); with Thos Agnew & Sons; Sir John Barran, Bart.; his sale, Christie's, 1 July 1906, lot 16 (250 guineas); anon. sale; Bruce Graham-Hersey, Dublin; anon. sale, Christie's, 5 March 1971, lot 16, bought Fine Art Society; The FORBES Magazine Collection, New York (P71040)

EXHIBITIONS: London, Royal Academy, 1849, no. 443; Manchester, City Art Gallery, *Art Treasures Exhibition*, 1857, no. 471; Glasgow, *Fine Art Loan Exhibition in Aid of the Royal Infirmary*, 1878; London, Royal Academy, 1883, no. 64; New York, Metropolitan Museum of Art, *The Royal Academy (1837–1901) Revisited*, 1975, no. 42, repr.

LITERATURE: *Art Journal*, 1849, p. 174; *Illustrated London News*, 26 May 1849, p. 350; *London Society*, no. 43 (1883), 217; *Daily Mirror*, 3 July 1905, p. 3; E. R. Firestone, 'John Linnell and the Picture Merchants', *Connoisseur*, Feb. 1973, p. 130

The picture shows Ulysses being put ashore at Ithaca. When it was first exhibited at the Royal Academy in 1849 it was accompanied in the catalogue by the following passage from Homer's *Odyssey*:

And first brought forth Ulysses: bed and all
That richly furnish't it; he still in thrall
Of all-subduing sleepe. Upon the sand
They set him softly down; and then, the strand
They strewed with all the goods he had bestowed
By the renowned Phoenicians

Linnell's historical landscapes usually drew on the Bible or Milton for their sources. This and *Ulysses Hunting the Boar on Mount Parnassus* of 1850/1 are the only examples recorded of Linnell using a classical source, undoubtedly the result of a specific commission. Joseph Gillott had previously commissioned William Collins to paint the subject – one which must have been even more uncharacteristic for him than it was for Linnell. Collins's death in 1847 prevented him from carrying it out. The commission was then passed on to Linnell, who worked on it throughout March, April and May of 1847 and did not finish the picture until August 1848. The painting evidently pleased its owner greatly, for when Gillott finally received the picture in November 1848 he immediately requested a companion for it. Subsequently he and Linnell were unable to agree on terms, and the second picture was never painted. *Ulysses* is exceptional in Linnell's oeuvre. In place of the English landscape scenery and natural colourings upon which even his more exotic subjects normally depend, the artist devised an imaginary landscape of brilliant oranges, yellows and ochres. The sense of looking into the setting sun recalls the landscapes of Claude, whose *Departure of the Queen of Sheba* Linnell may have seen in the National Gallery. A closer connection may be made with Turner, whose painting *Ulysses Deriding Polyphemus* (132.5 × 203.0 cm, National Gallery, London) was exhibited at the Royal Academy in 1829. Linnell's painting received some censure on its appearance in 1849 because it was 'without immediate reference to nature'.

Lent from The FORBES Magazine Collection, New York

95 Christ and the Woman of Samaria at Jacob's Well

Oil on panel. 19.5 × 42.4 cm

Torn label, *verso*, in Linnell's hand: 'Christ and the woman of Sa... / ... J. Linnell / Porchester Terrace'; on another label: 'Linnell'

COLLECTIONS: Sotheby's, 15 March 1978, lot 6; with Alan Cowie, from whom purchased by the Fitzwilliam Museum (Fairhaven Fund), 1981 (PD.22–1981)

Three versions of this composition are recorded in Linnell's 'Landscape Sketchbook' in the British Museum. The first, dated 1828 and exhibited at the British Institute in 1829, is now in the Huntington Library and Art Gallery, San Marino, California (no. 66.55). It is the smallest; an upright composition, close to Palmer in technique and mood. The second, to which this sketch is most intimately related, was painted in 1850 for Mr Holmes of Birmingham as a companion to *Philip Baptising the Ethiopian* (cat. no. 92) and exhibited that year at the Royal Academy (no. 474). The third version was begun in August 1838 (Linnell MSS., 'Journal') in watercolour and not completed until 1866, when Linnell finished it in oil. The subject was one which preoccupied Linnell for nearly forty years.

The date of the Fitzwilliam sketch is uncertain. The composition is closest to the painting exhibited in 1850, but the handling of the paint, which is very loose and sketchy, is typical of Linnell's later work and is characteristic of the 1860s. It may be that, rather than being a preparatory sketch for the large painting, this is a *ricordo* painted after the original had been sold.

Lent by the Fitzwilliam Museum, Cambridge

96 The Rise of the River

Oil on canvas. 130.0 × 93.76 cm

Signed and dated, below, 'John Linnell / 1857'

COLLECTIONS: Painted for Messrs Hooper & Wass; Thomas Wrigley, by whose children presented to the town of Bury

EXHIBITION: Manchester, City Art Gallery, *Art Treasures Exhibition*, 1857, no. 303

LITERATURE: British Museum, Linnell's 'Landscape Sketchbook'; Story, *Linnell*, II, p. 275

The painting was commissioned by the dealers Hooper & Wass by an agreement dated 4 March 1857: 'Messrs Hooper and Wass agree to pay Mr Linnell four hundred guineas for a picture of "The Rise of the River" size 48″ × 36″ ... If the above picture is enlarged to the size or nearly of "The Sunny Gleaners" viz. 52″ × 36″ the said enlargement [illeg. word] is to be at the expense of Messrs H and W.' Linnell worked on the painting from January to May 1857, spending twenty days on the picture in all. The figures portrayed fleeing from the flooded river are reminiscent of those in Gainsborough's 'fancy pictures' in their dress and in their ruddy features. Linnell is a master of the nineteenth-century pastoral, in which the reality of rural life is softened into a fiction of contentment, threatened only by natural disasters such as a flooded river or failed harvest. *The*

Rise of the River is a good example of how Linnell presented such a vague image with great drama and conviction.

Lent by the Bury Art Gallery & Museum

97 Mid-Day Rest (Windsor Forest)

Oil on canvas. 71.3 × 99.4 cm
Signed and dated, lower right, 'J. Linnell 1863'
COLLECTIONS: J. E. Yates, by whom bequeathed to the City of Manchester Art Galleries, 1934 (1934.418)
LITERATURE: British Museum, Linnell's 'Landscape Sketchbook'; Story, *Linnell*, II, p. 278; *Concise Catalogue of British Paintings* (Manchester (City Art Gallery), 1976), I, p. 120, repr.

There is a sketch of this picture in Linnell's 'Landscape Sketchbook' which explains that the picture was painted for William Agnew, with another smaller one of Windsor Forest sized '28 × 20'. Linnell also provided Agnew with a drawing of the Manchester painting size '10 × 14'. Linnell's correspondence with Agnew for 1863 refers indiscriminately to 'my Windsor Forest picture'. Linnell often provided Agnew with a description of the gestation of a picture and his estimate of it, presumably so that this would help to sell the picture. Referring to the Windsor Forest pictures, he states that they show 'Windsor Forest as it was 50 years ago'. Indeed it was; he did not revisit the area after 1815.

Lent by the City of Manchester Art Galleries

98 A Coming Storm

Oil on canvas. 130.8 × 168.9 cm
Signed and dated below, left of centre, 'J. Linnell 1873'
COLLECTIONS: E. F. White; John McGavin, who bequeathed it to the Glasgow Art Gallery & Museum in 1881 (no. 648)
EXHIBITIONS: London, Royal Academy, 1873, no. 87; Manchester, *Royal Jubilee Exhibitions,* 1883, no. 664; London, Royal Academy, *Bicentenary Exhibition,* 1968–9, no. 214, and *This Brilliant Year,* 1977, no. 149
LITERATURE: *Art Journal,* 1873; Story, *Linnell,* II, p. 281; G. Reynolds, *Victorian Painting* (London, 1966), p. 28, pl. 15; *Summary Catalogue of British Paintings* (Glasgow (Art Gallery and Museum), 1971), p. 44

Painted when the artist was aged eighty-one, *A Coming Storm,* like *The Last Load* (cat. no. 99), shows how Linnell's vision of landscape developed into a dramatic, apocalyptic view of nature, in which man is reduced to the size of an ant and the features of nature matter less than the total effect. According to Linnell's 'Journal', he painted another, smaller version of this picture 'with slight variations, size 39 × 28‴'.

Lent by the Glasgow Art Gallery & Museum, Kelvingrove

99 The Last Load

Oil on canvas: 125 × 165 cm
Signed, lower right, 'J Linnell'
COLLECTIONS: Edward Fox White; Viscount Ridley; George Audley, who presented it
to the Walker Art Gallery, Liverpool, 1925 (no. 2883)
EXHIBITION: London, Pall Mall Gallery, 1875, no. 5
LITERATURE: Linnell MSS., 'Journal' for 1873–5; British Museum, Linnell's 'Landscape
Sketchbook'; Story, *Linnell*, II, p. 282; *The Walker Art Gallery Illustrated Catalogue of the
Permanent Collection* (Liverpool, 1927), repr.

Linnell seems to have spent an unusually long time – two years – on this picture,
which was bought on its completion by his dealer, Edward Fox White, in 1875.
Until recently the painting was known as *The Last Gleam before the Storm*, but this
is disproved by Linnell's sketchbook; the *Last Gleam* was painted in 1847–8 and
is now in a private collection.

Lent by the Walker Art Gallery, Liverpool

100 Sketchbooks

(a) Landscapes

Ink with pencil annotations. 195 × 167 mm
Inscribed in ink, flyleaf, 'Landscapes and other pictures not Portraits / Painted by John
Linnell Senr / From 1807. The first exhibited / To ——— / For my son James Thos Linnell /
October 1879 / John Linnell Senr'
COLLECTIONS: By descent from the artist; purchased by the British Museum
(1976–1–31–7)

(b) Portraits

Ink with pencil annotations. 190 × 165 mm
Inscribed, flyleaf, 'Outlines & Account of Portraits / by John Linnell'
COLLECTIONS: By descent from the artist; purchased by the British Museum
(1976–1–31–6)

These two volumes form Linnell's 'Liber Veritatis', which he produced in 1879
for the benefit of his son James. The information in them is based on his
'Journals', 'Cash Account Books' and memory, which in the case of sizes is not
always reliable. Nor do the volumes record the many studies and small oil
sketches done for his own benefit.

Lent by the Trustees of the British Museum

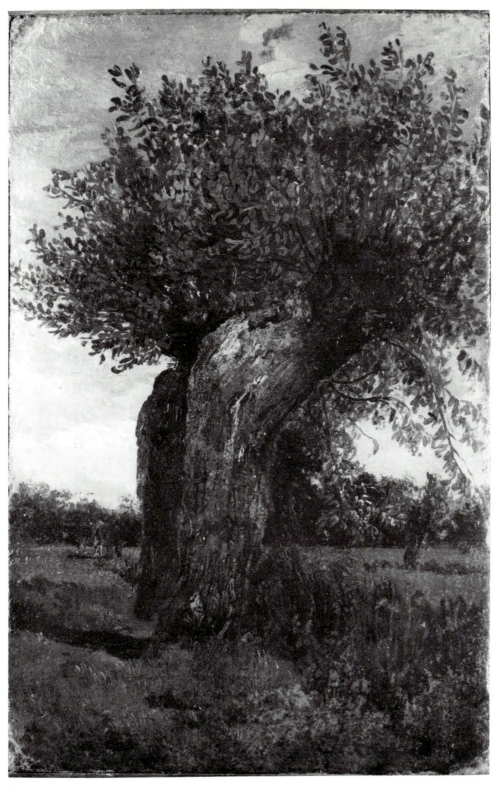

Cat. no. 1

45

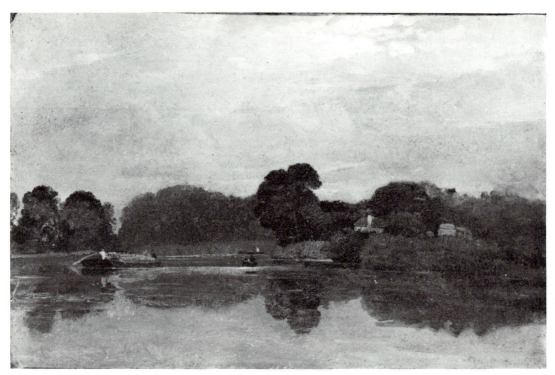

Cat. no. 2

Cat. no. 3

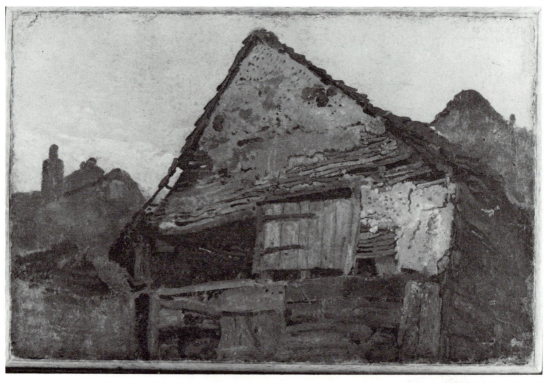

Cat. no. 4

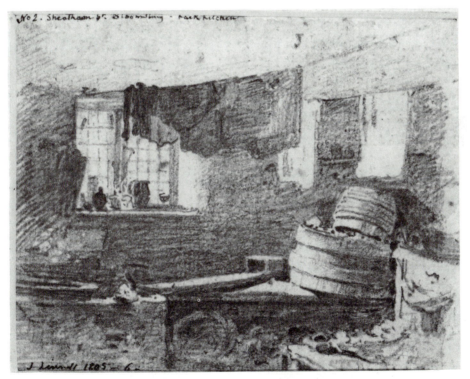

Cat. no. 5

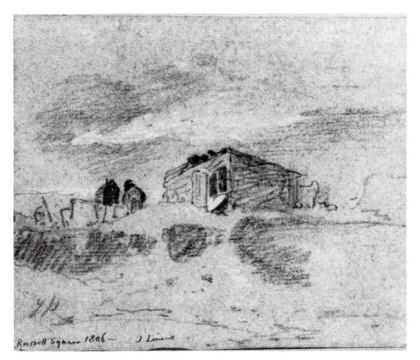

Cat. no. 6a

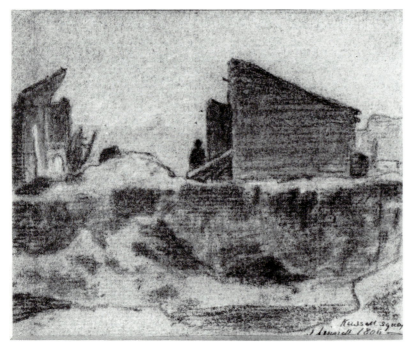

Cat. no. 6b

48

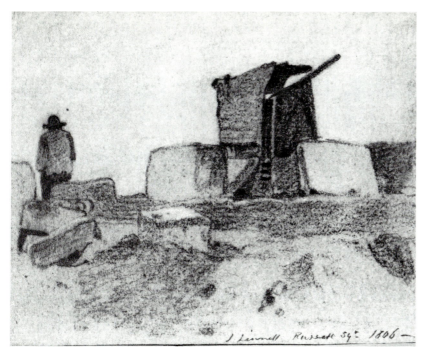

Cat. no. 6c

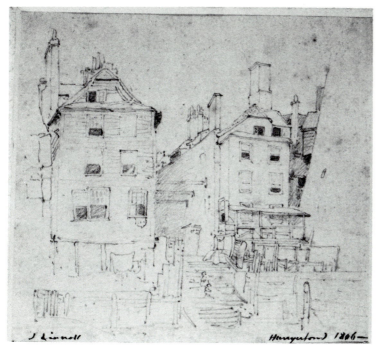

Cat. no. 7

49

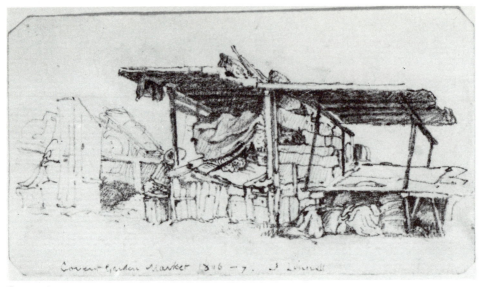

Cat. no. 8

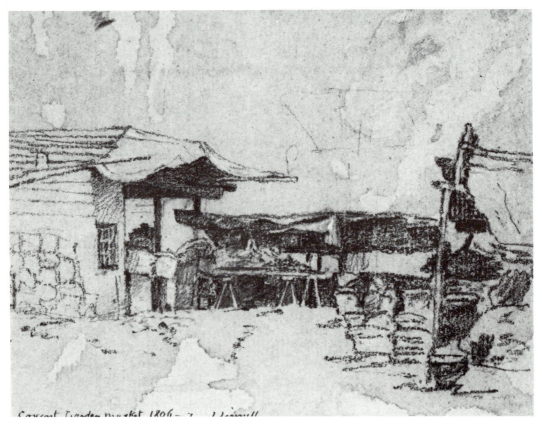

Cat. no. 9

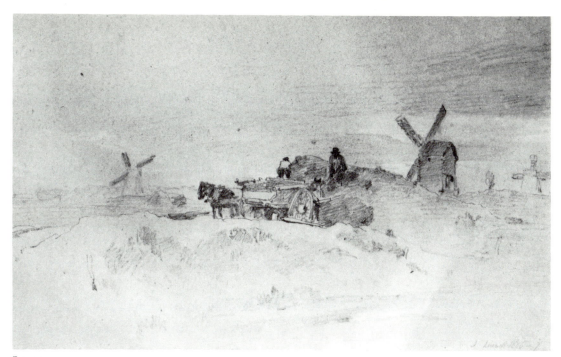

Cat. no. 10

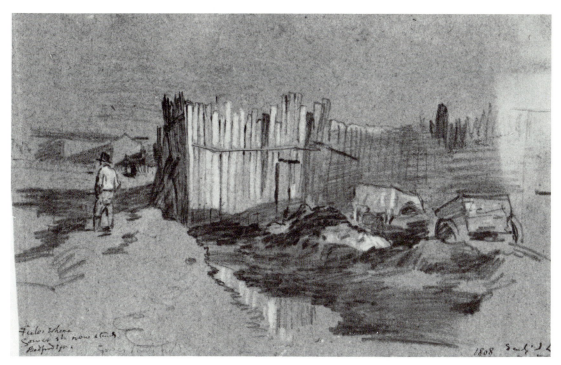

Cat. no. 11

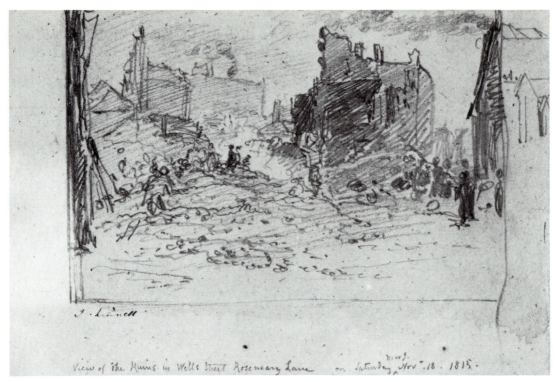

View of the Ruins in Wells Street Rosemary Lane on Saturday Nov.ʳ 18 - 1815 -

Cat. no. 12

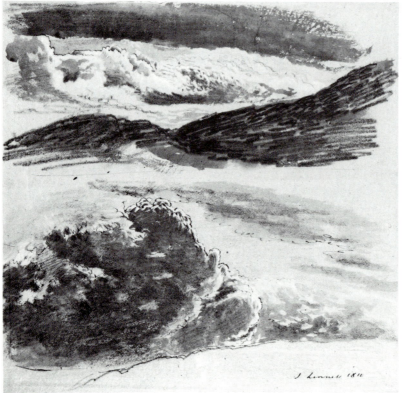

Cat. no. 13a

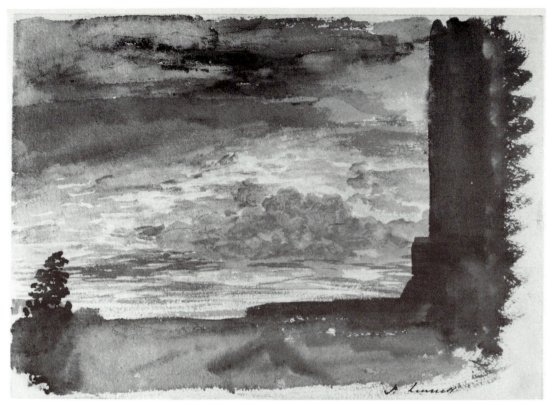

Cat. no. 13b

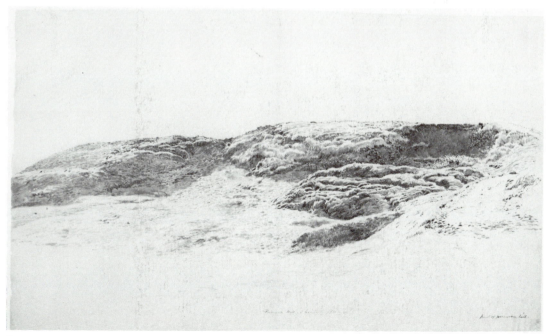

Cat. no. 14

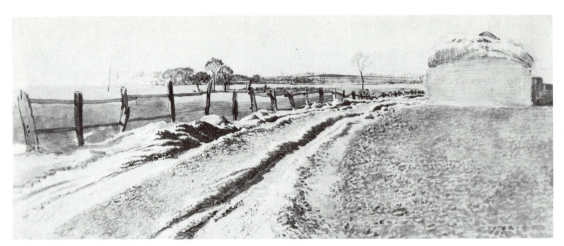

Cat. no. 15

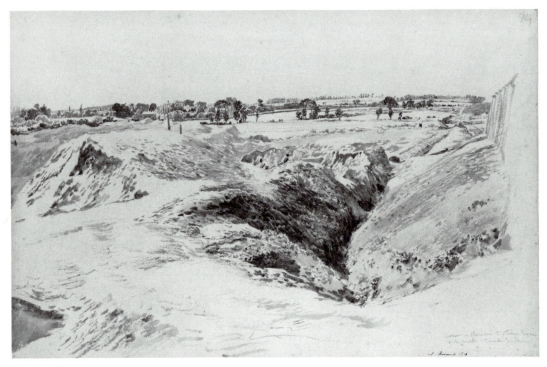

Cat. no. 16

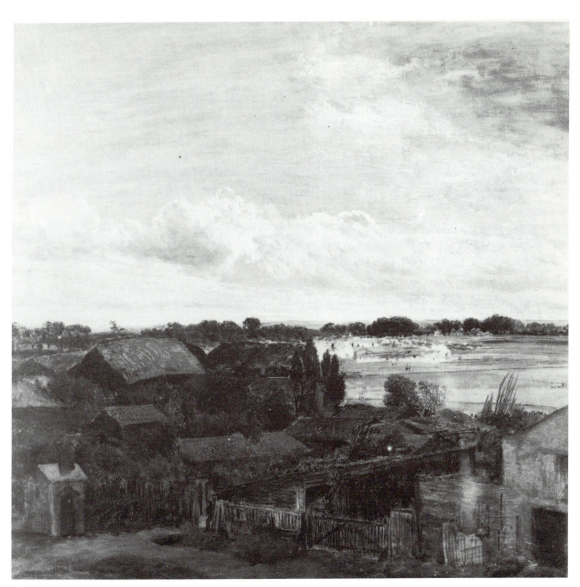

Cat. no. 17

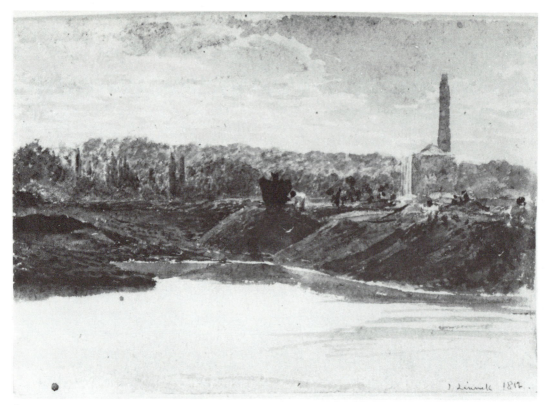

Cat. no. 18

Cat. no. 19

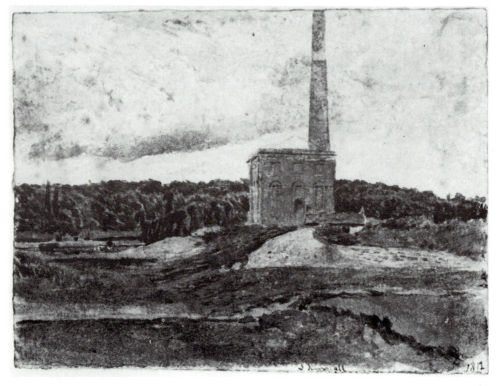

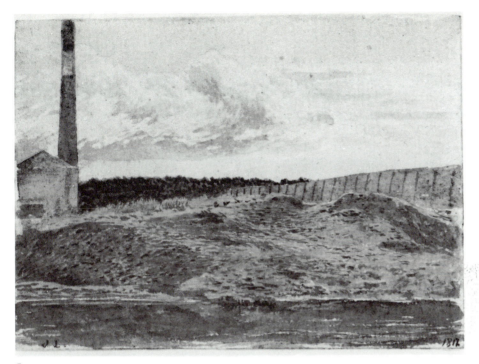

Cat. no. 20

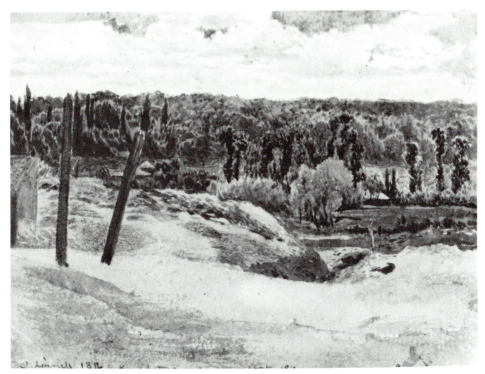

Cat. no. 21

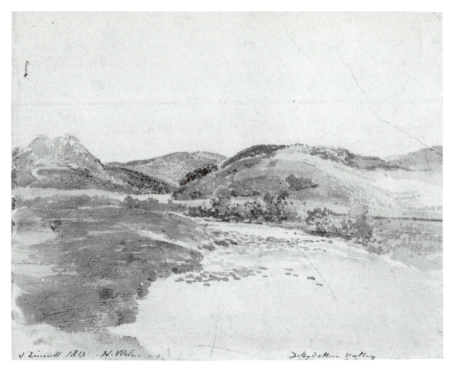

Cat. no. 23

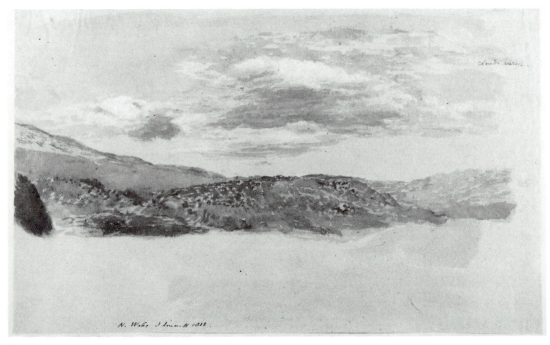

Cat. no. 24

Cat. no. 25

Cat. no. 26

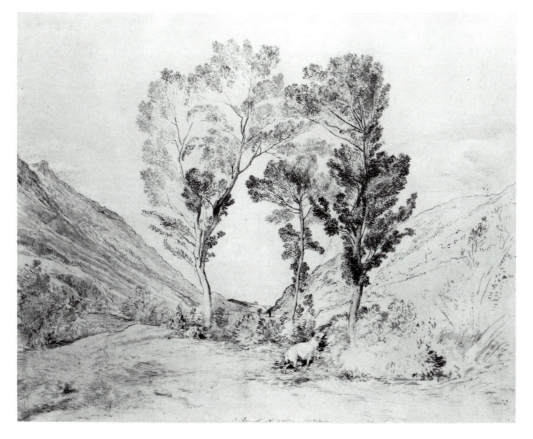

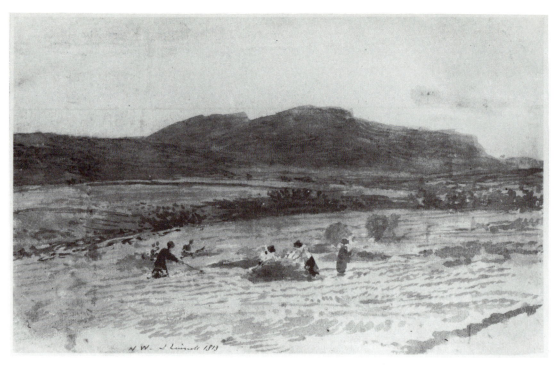

Cat. no. 27

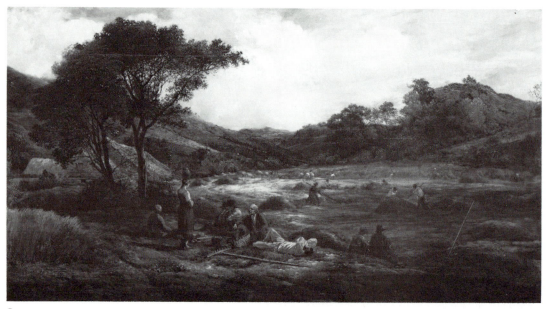

Cat. no. 28

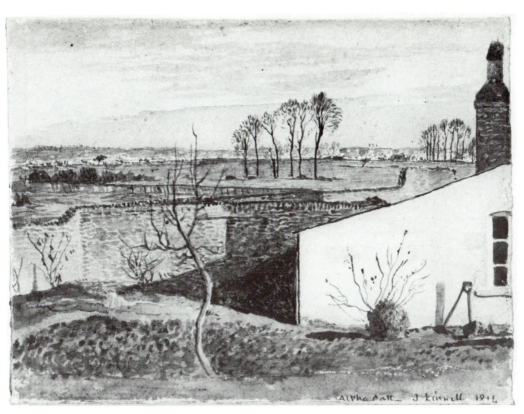

Cat. no. 29

Cat. no. 31

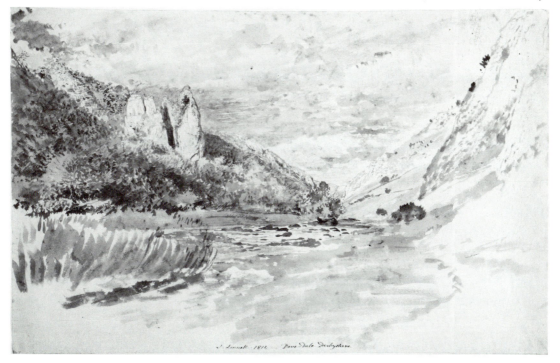

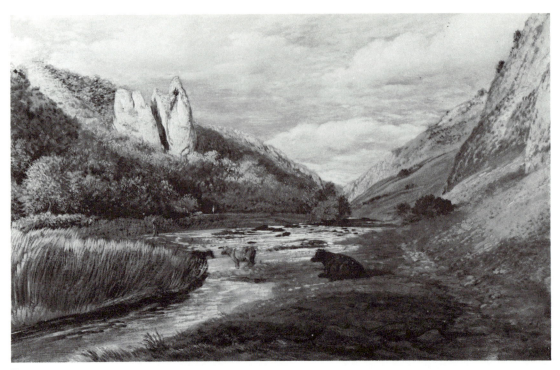

Cat. no. 32

Cat. no. 33

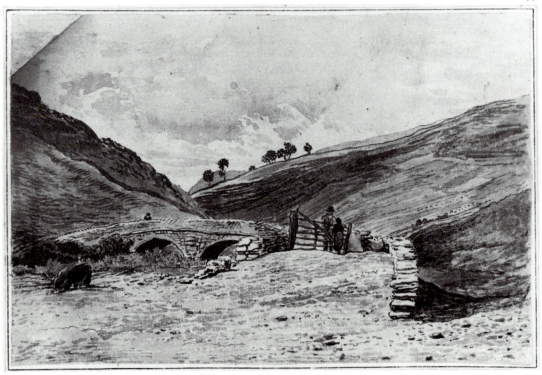

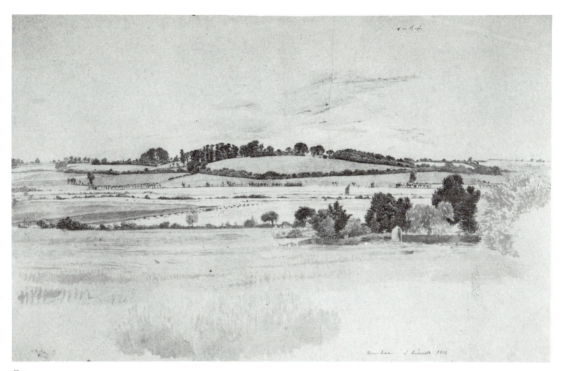

Cat. no. 34

Cat. no. 35

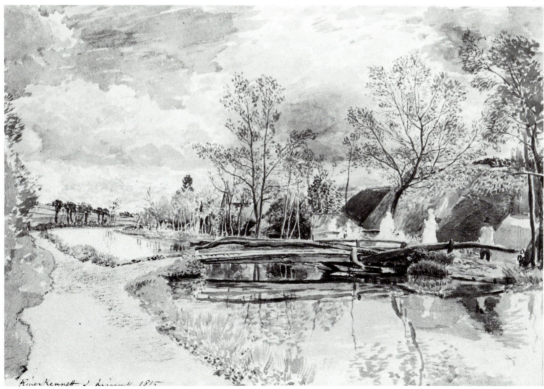

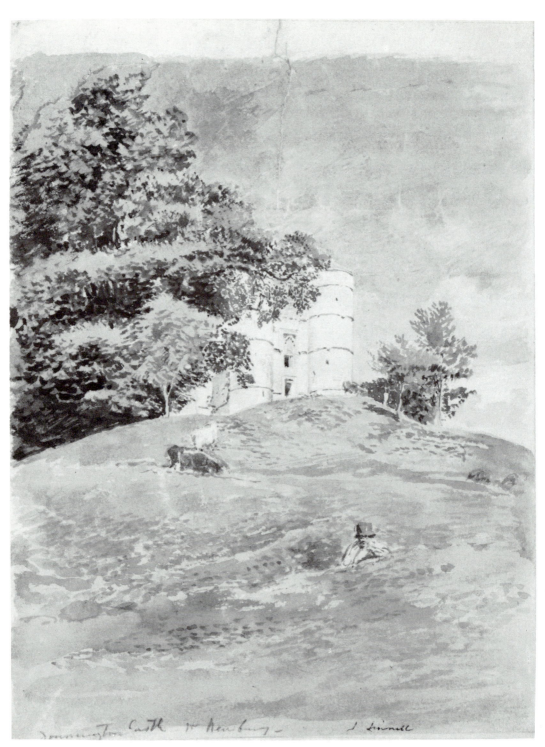

Donnington Castle nr Newbury — J Linnell

Cat. no. 37

Cat. no. 38

Cat. no. 39

Cat. no. 40

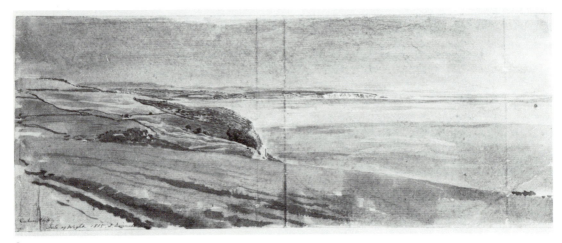

Cat. no. 41

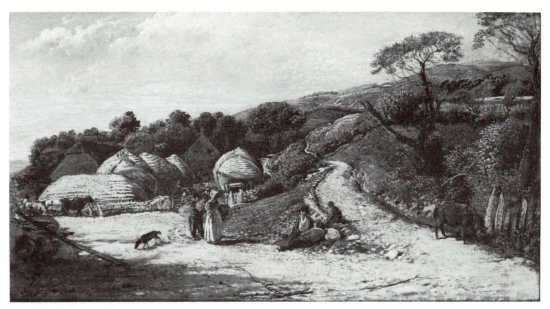

Cat. no. 42

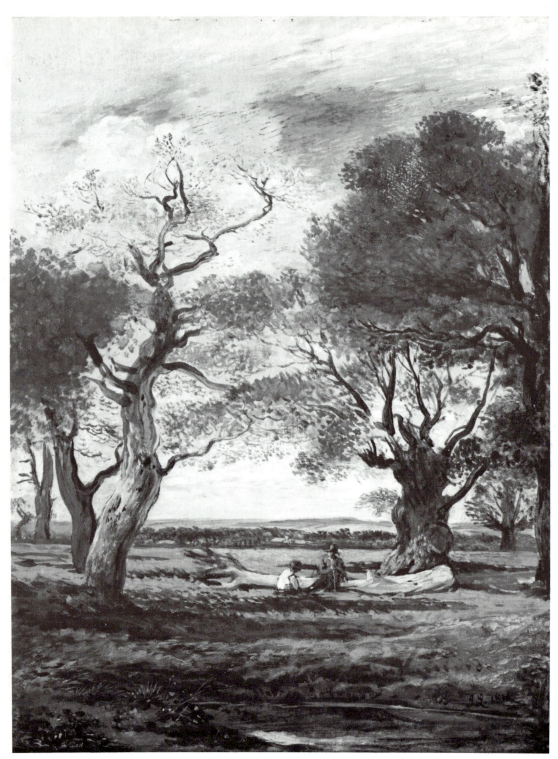

Cat. no. 43

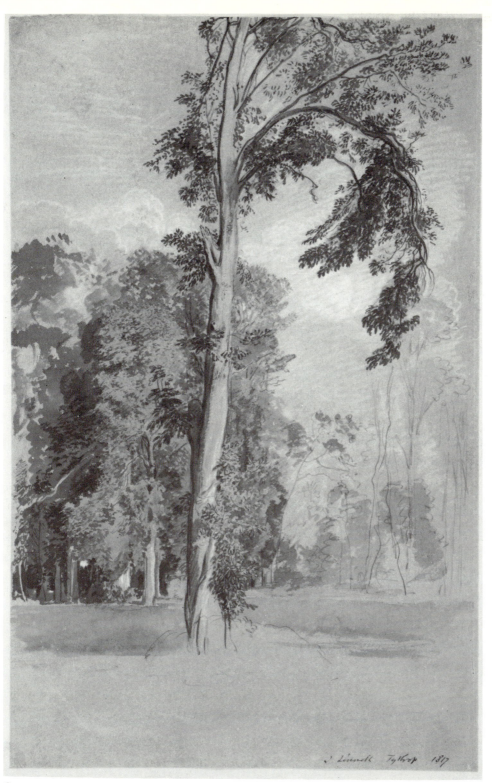

Cat. no. 44

Cat. no. 45

Cat. no. 46

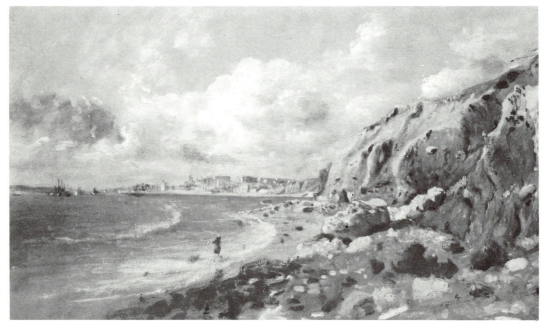

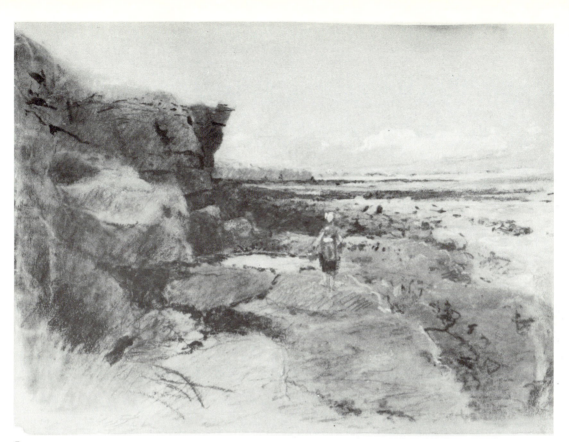

Cat. no. 47

Cat. no. 48

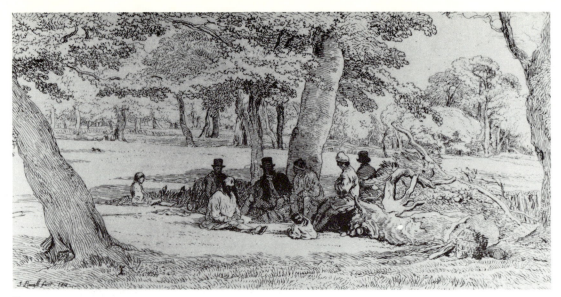

Cat. no. 49

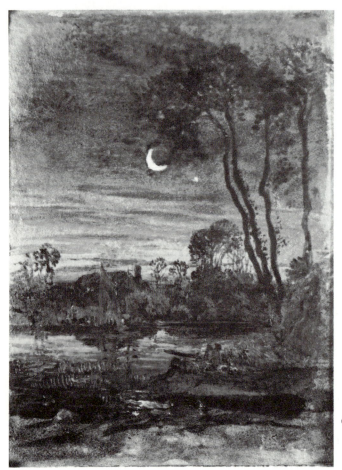

Cat. no. 50

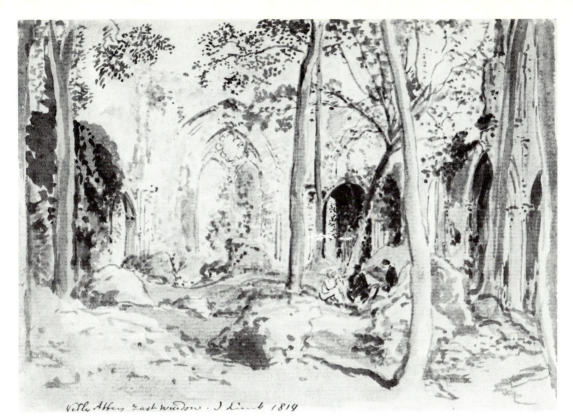

Netley Abbey, East window · J Linnell 1819

Cat. no. 51

Cat. no. 52

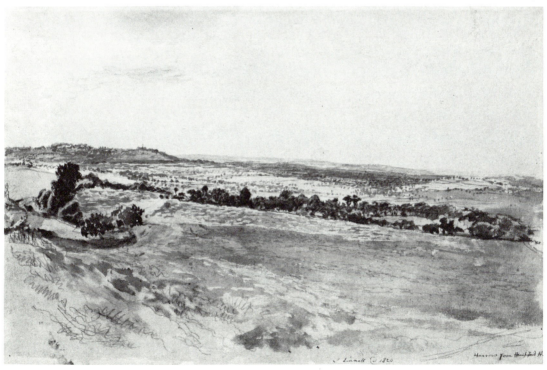

J Linnell 1820 Harrow from Hampstead H.

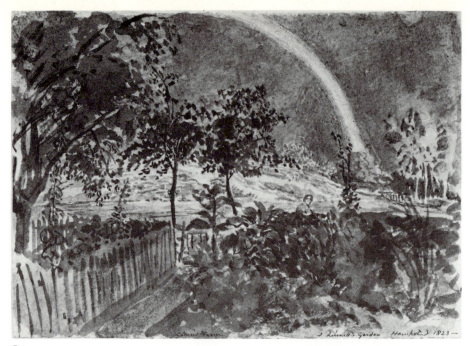

Cat. no. 53

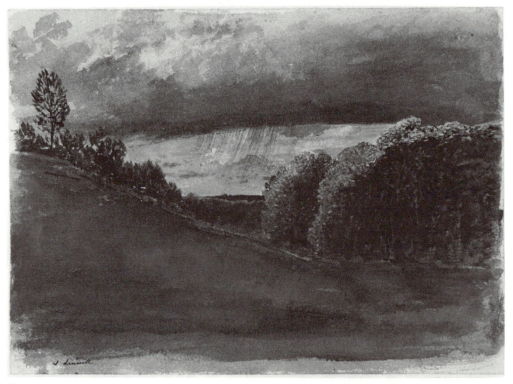

Cat. no. 54

74

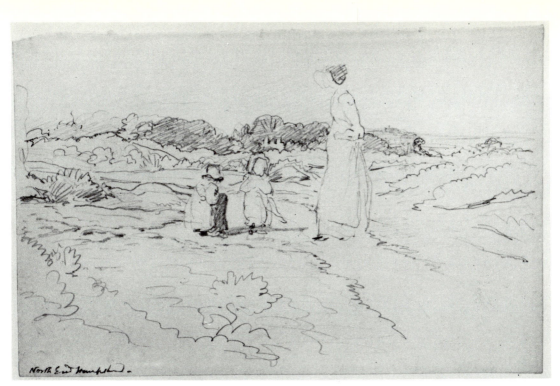

Cat. no. 55a

Cat. no. 55b

Cat. no. 55c

Cat. no. 55d

76

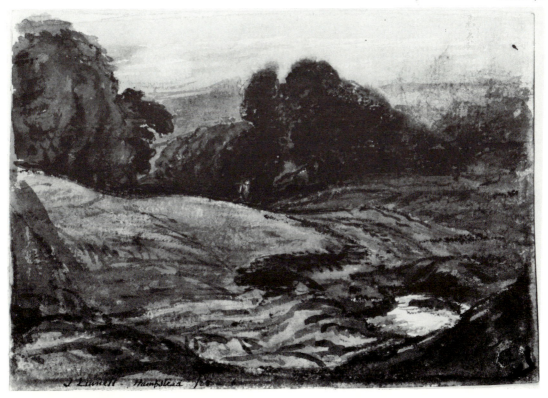

Cat. no. 55e

Cat. no. 56

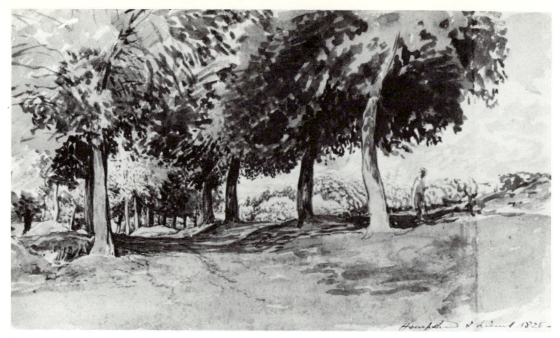

Cat. no. 57

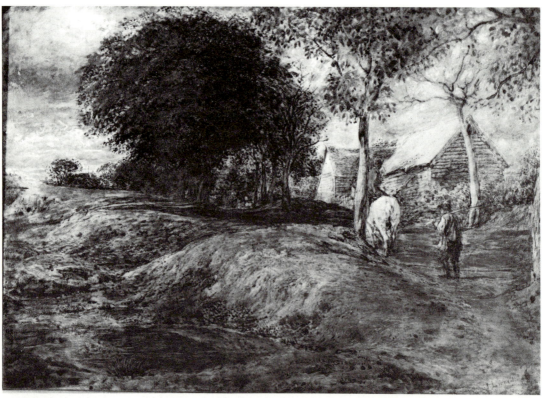

Cat. no. 58

78

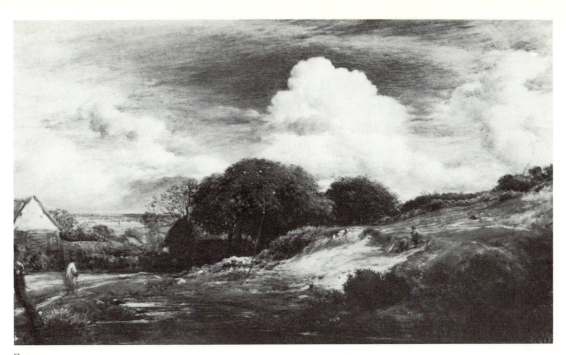

Cat. no. 59

Cat. no. 60

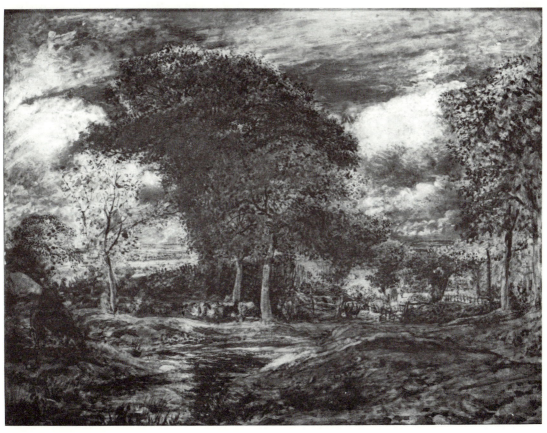

Cat. no. 62

Cat. no. 63

Cat. no. 64

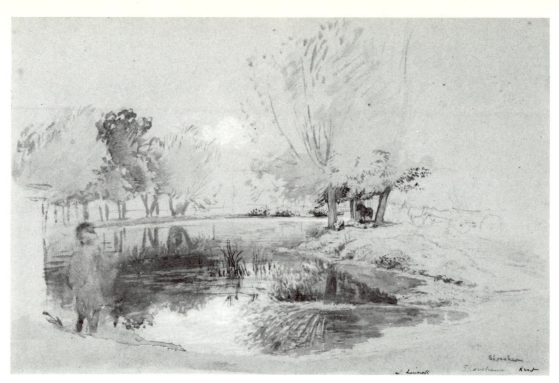

Cat. no. 65

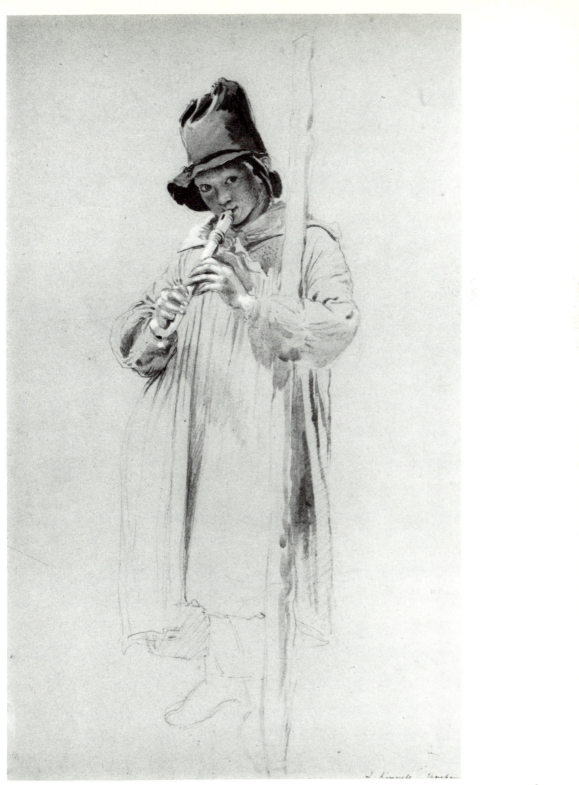

Cat. no. 66

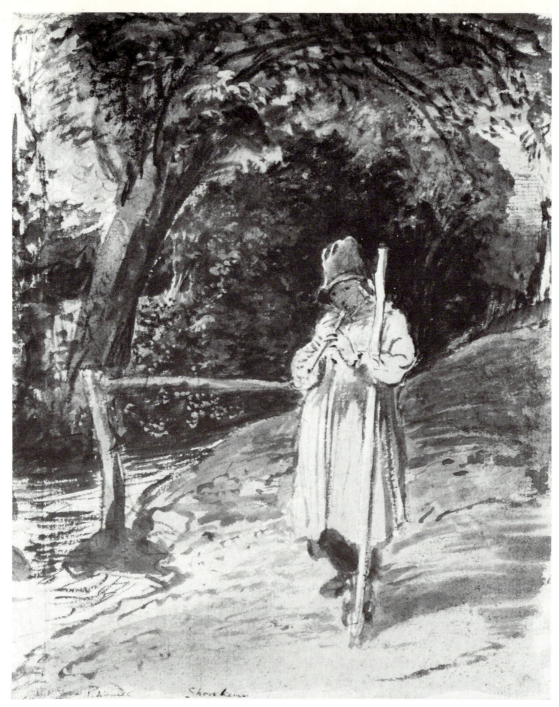

Cat. no. 67

84

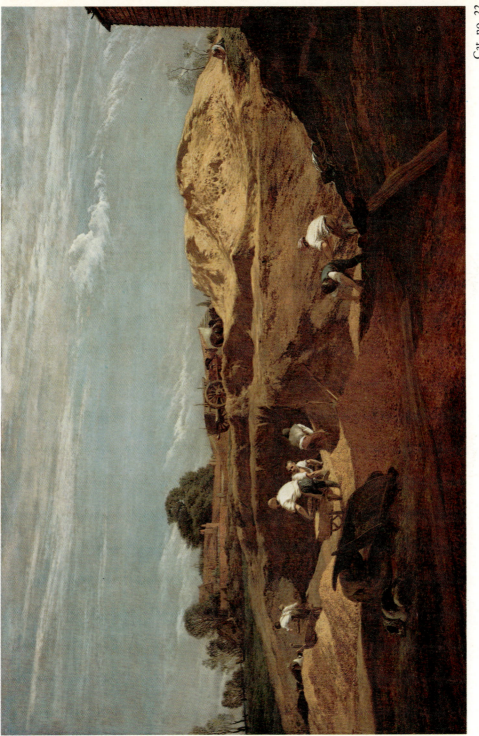

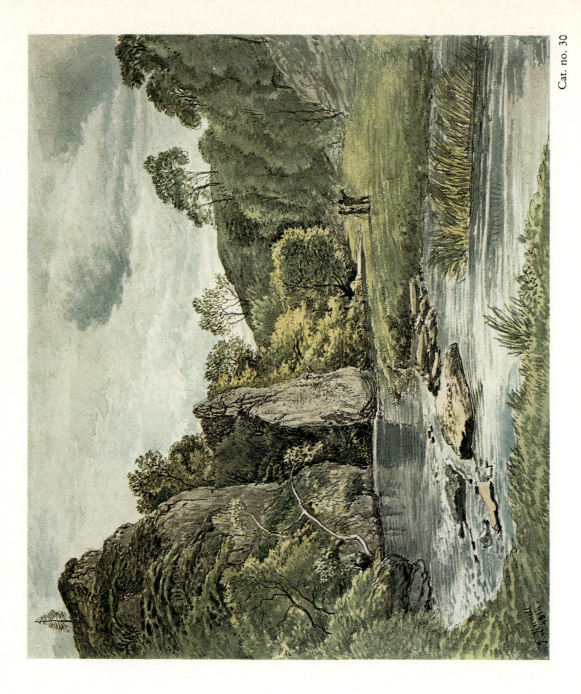

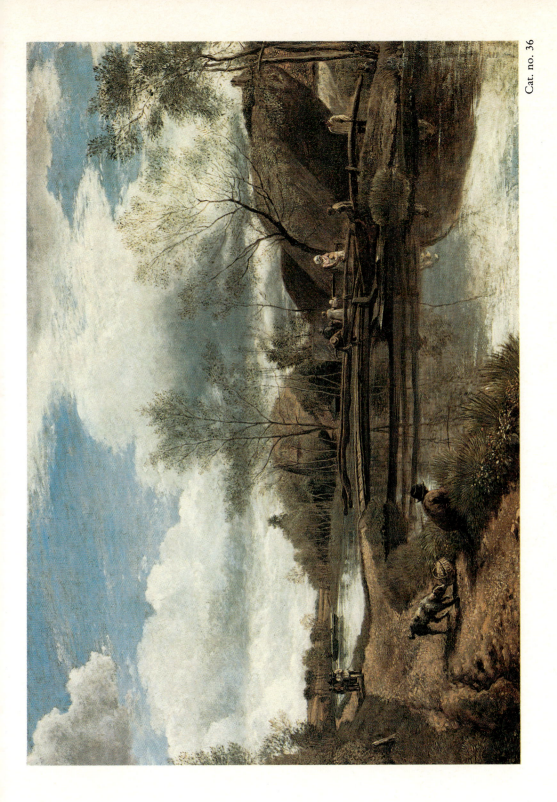

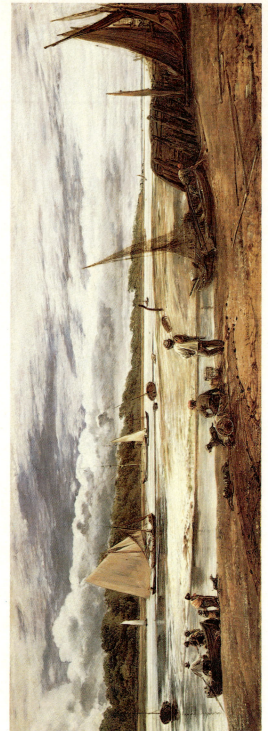

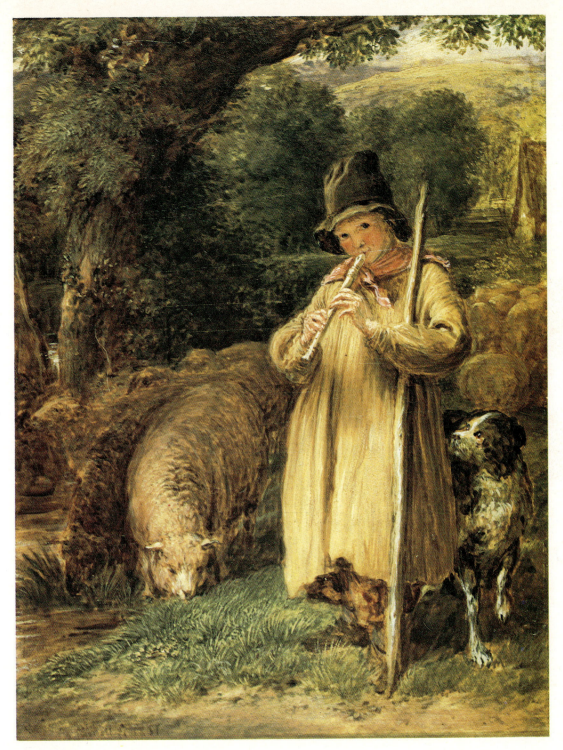

Cat. no. 68

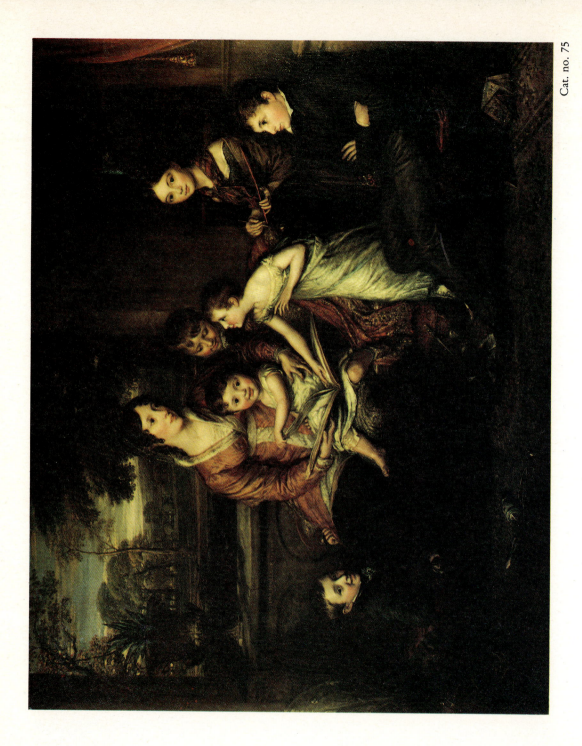

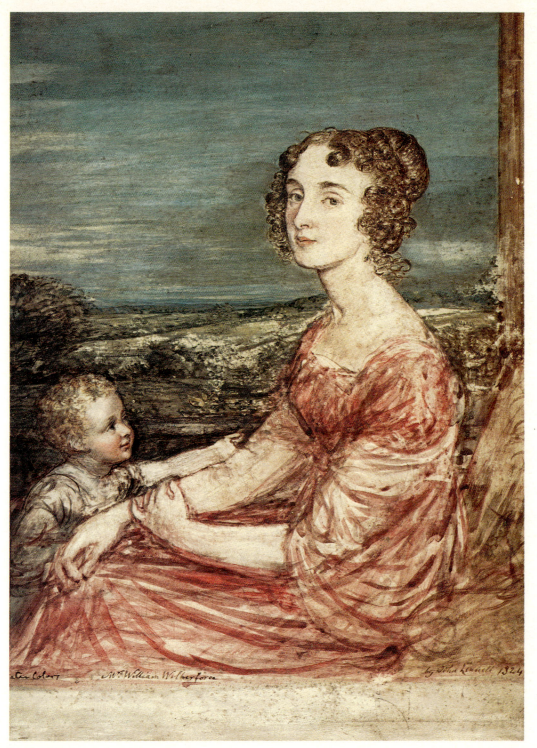

water Colors Mrs William Wilberforce by John Linnell 1824

Cat. no. 81

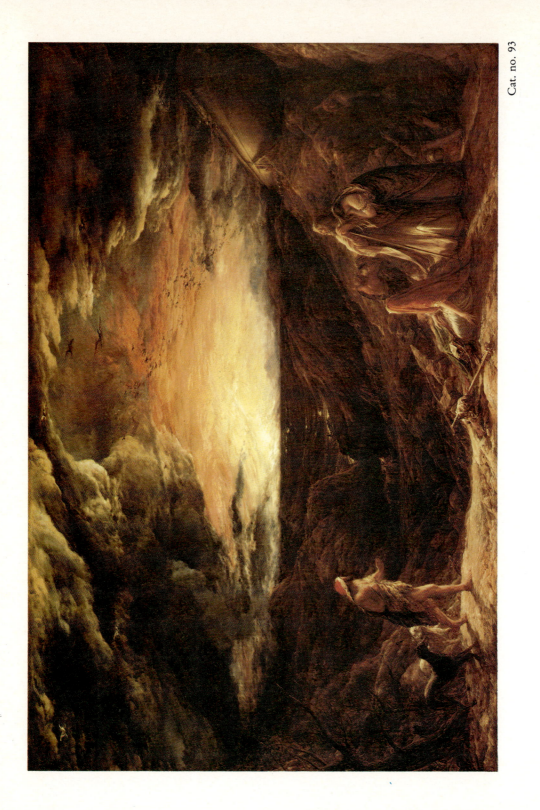

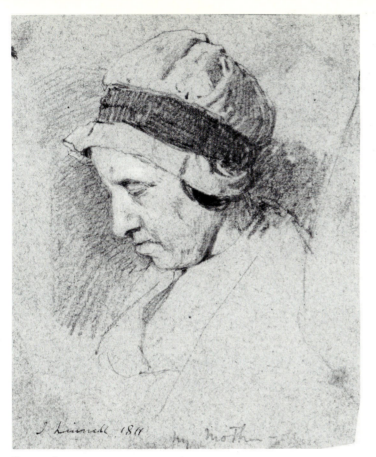

Cat. no. 69

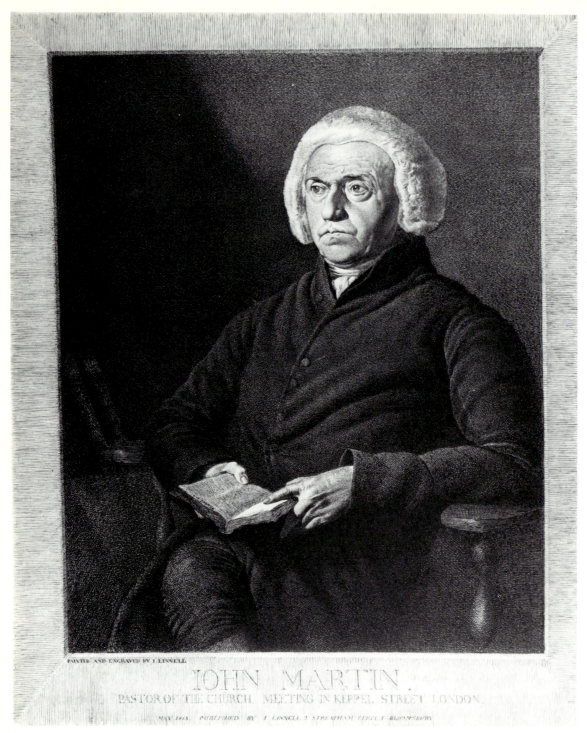

PAINTED AND ENGRAVED BY J LINNELL

JOHN MARTIN
PASTOR OF THE CHURCH MEETING IN KEPPEL STREET LONDON

MAY 1815. PUBLISHED BY J LINNELL 2 STREATHAM STREET BLOOMSBURY

Cat. no. 70

86

 J. Linnell 1815

Cat. no. 71

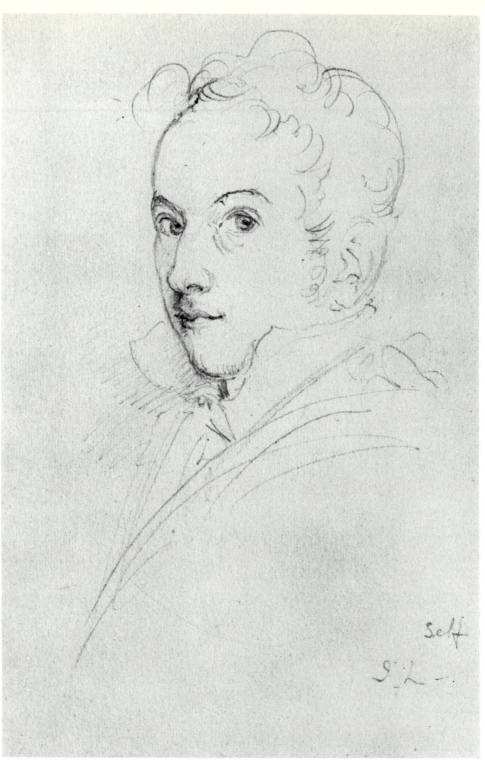

Cat. no. 72
88

Cat. no. 73

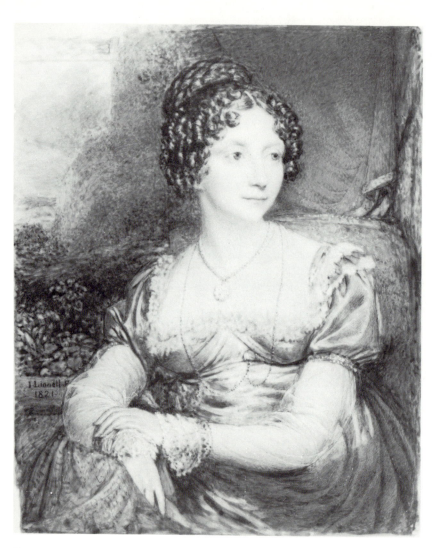

Cat. no. 74

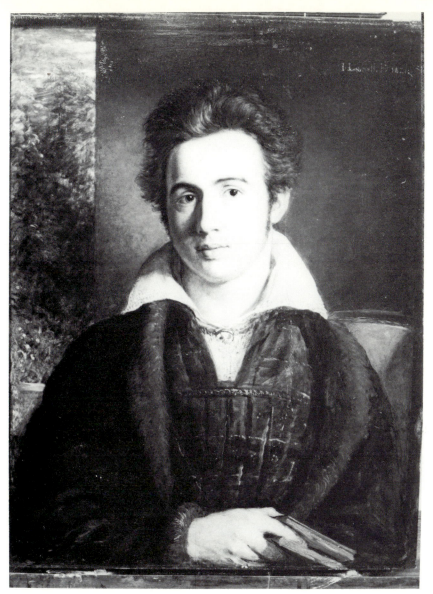

Cat. no. 76

Cat. no. 77

Cat. no. 78

92

Cat. no. 79

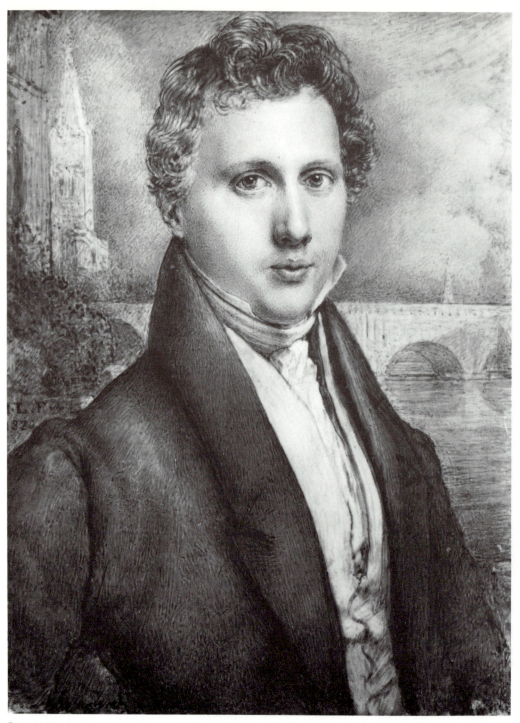

Cat. no. 80

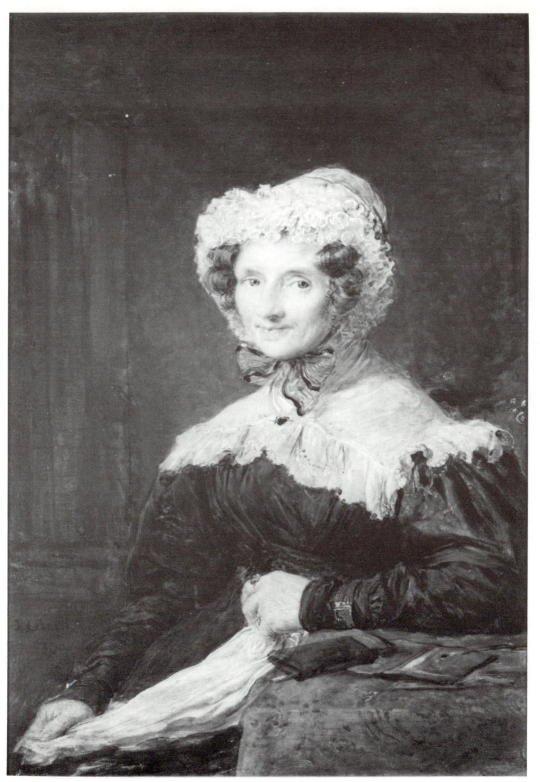

Cat. no. 82

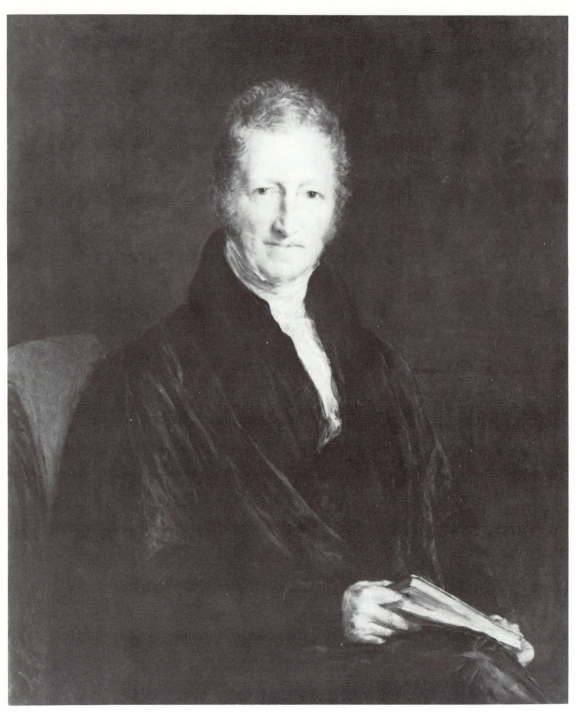

Cat. no. 83

96

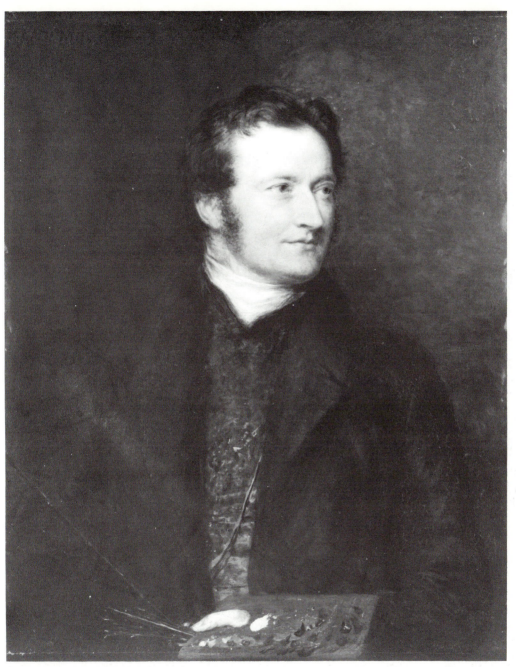

Cat. no. 84

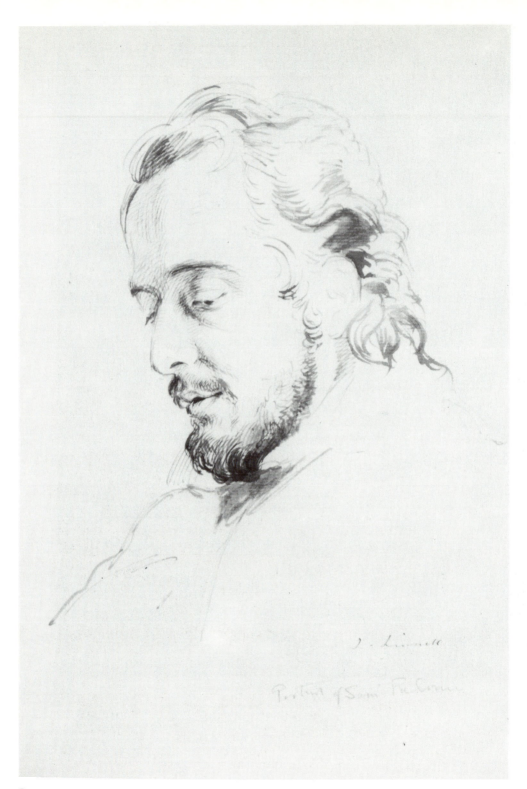

Cat. no. 85

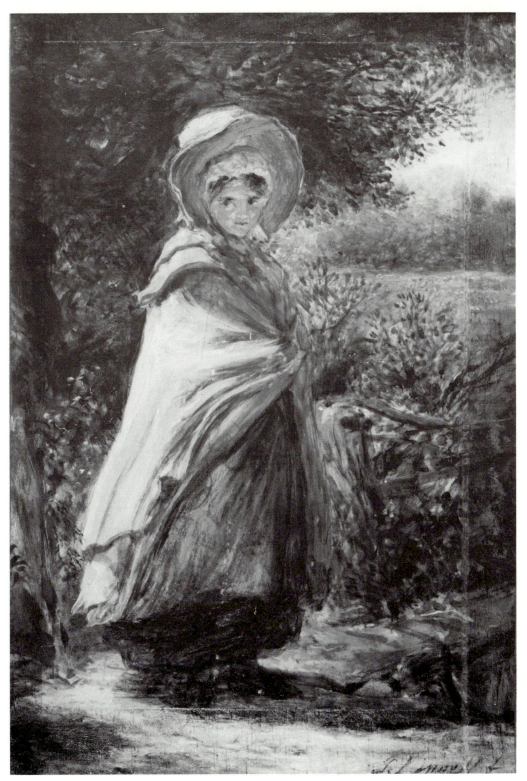

Cat. no. 86

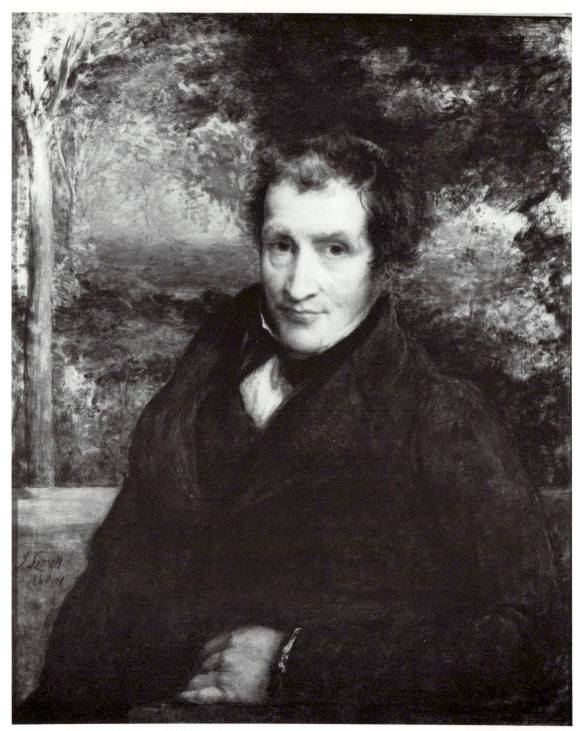

Cat. no. 87

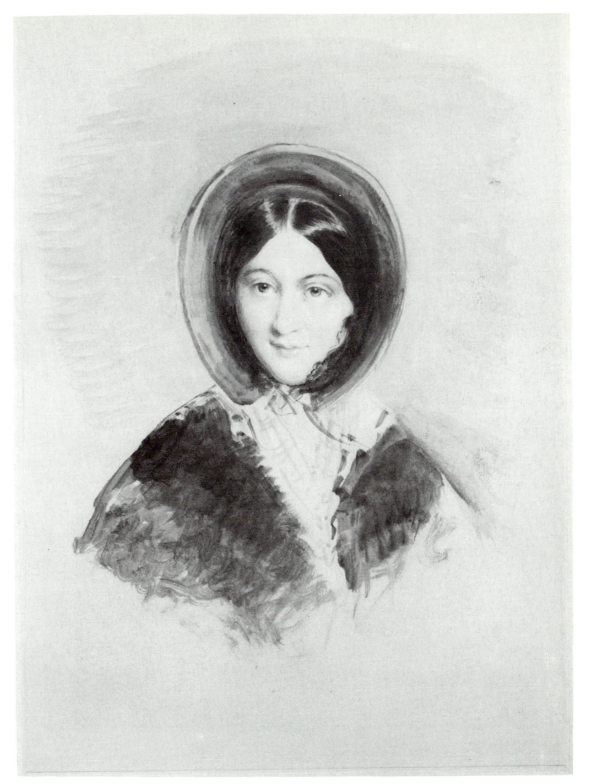

Cat. no. 88

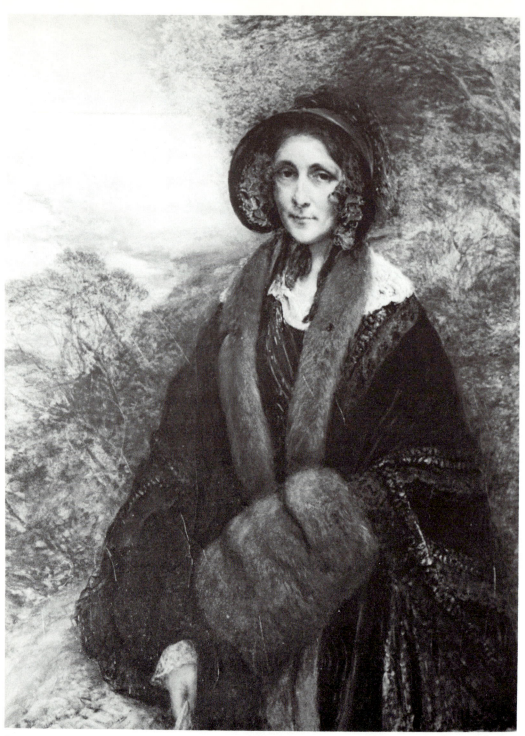

Cat. no. 89

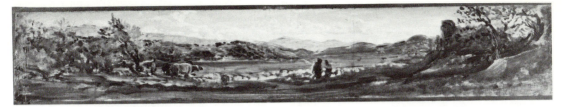

Cat. no. 90

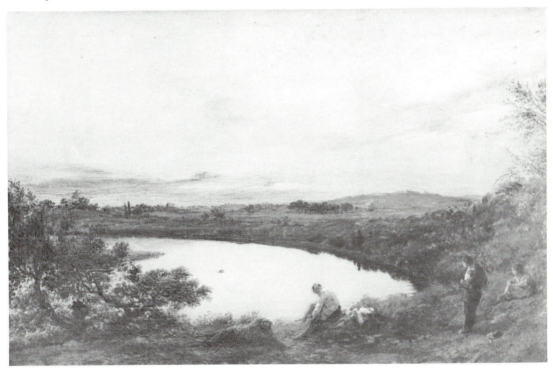

Cat. no. 91

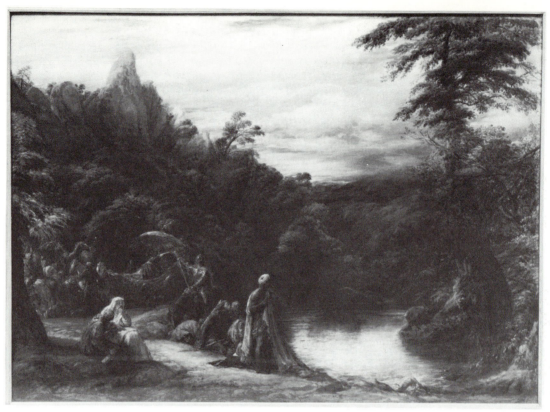

Cat. no. 92

Cat. no. 94

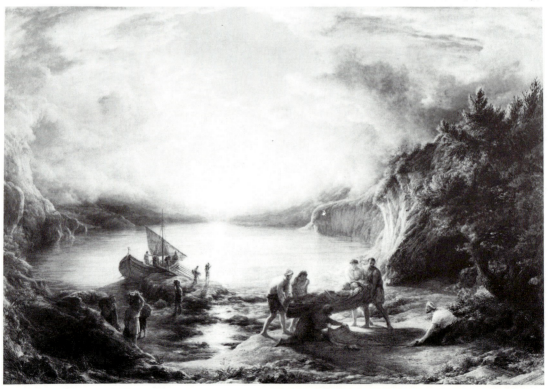

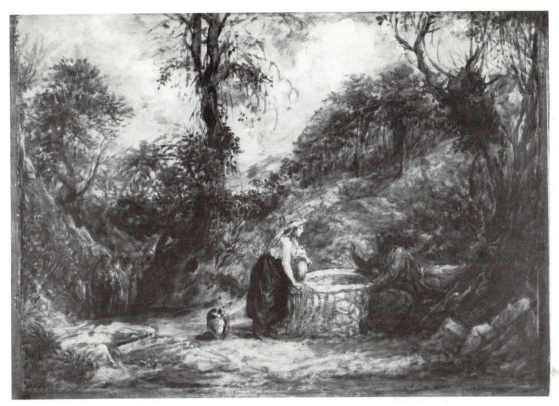

Cat. no. 95

Cat. no. 96

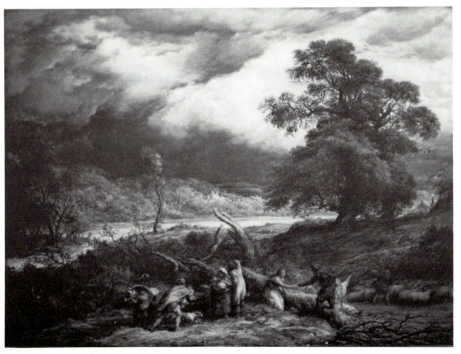

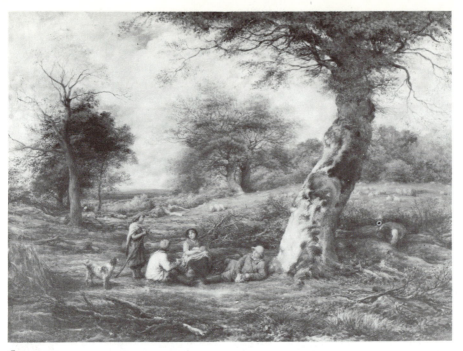

Cat. no. 97

Cat. no. 98

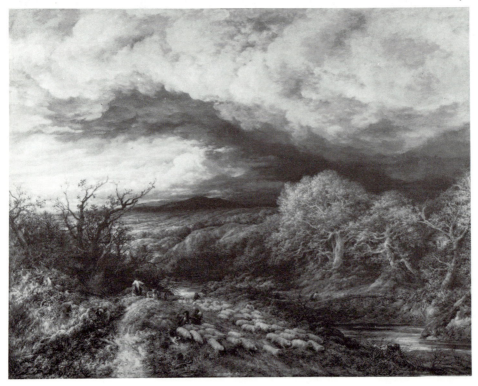

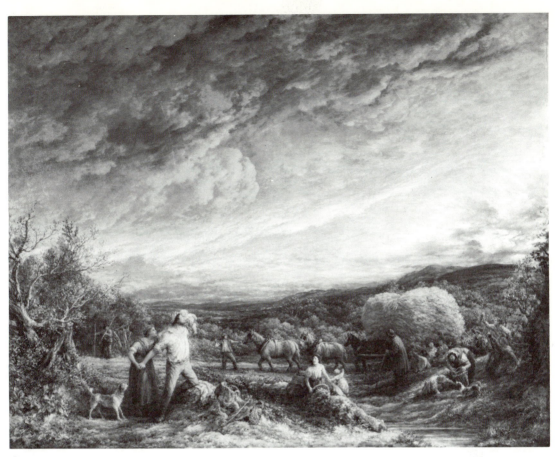

Cat. no. 99